The
FIGURE
DRAWING
Workbook

The
FIGURE
DRAWING
Workbook

John Raynes

A step-by-step guide to drawing the human figure

First published in Great Britain in 1997 by
Collins & Brown Limited
London House
Greate Eastern Wharf
Parkgate Road
London SW11 4NQ

3 5 7 9 8 6 4 2

British Library Cataloguing-in-Publication Data:
A catalogue record for this book is available from
the British Library.

ISBN 1 85585 289 6 (hb)
ISBN 1 85585 298 5 (pb)

Conceived, edited and designed by
Collins & Brown Limited

Editorial Director: Sarah Hoggett
Editors: Matthew Rake and Katie Bent
Art Director: Roger Bristow
Senior Art Editor: Julia Ward-Hastelow
Photography: John Raynes and
Sampson Lloyd

Reproduction by Bright Arts, Singapore
Printed in Hong Kong

INTRODUCTION 6

CONTENTS

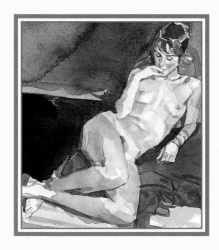

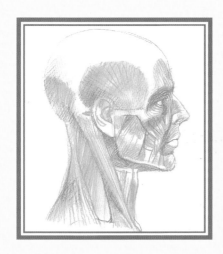

INTRODUCTION

*The essence of figure drawing is to draw what you see. In this book I
hope to suggest how you can express this new vision through imaginative
poses, a variety of media and a little background knowledge.*

MY INTENTION IN THIS BOOK IS, above all, to help you to look at the figure with fresh eyes: simply to draw what you see. This may sound straightforward. But the difficulties that beginners (and others) encounter when drawing the figure are nearly always traceable to the fact that we subconsciously tend to rely on our existing knowledge of shapes and proportions rather than draw what is actually there. Our memory of a leg, for example, is of a form that is long and loosely cylindrical. When observed from one end it can appear to be almost spherical. This fact tends to be over-ridden by our remembered knowledge. This is because our subconscious vision compensates for the tricks of perspective, proportion and fall of light on our surroundings – our brain fills in the missing details that we know are there. When figure artists approach their subject they must retrain their brains to look objectively.

By closely observing a live model in a variety of poses and from a variety of viewpoints, you will be constantly surprised by what you see. Different body parts will assume unexpected proportions and shapes, and they will relate to each other in unanticipated ways. Similarly the way light falls on the body and the way it changes the colour of flesh tones may also be at odds with your preconceptions. To draw objectively, therefore, you have to believe in the evidence before your eyes. If you understand from the beginning that you have, in a sense, to outwit your subconscious then you will progress more quickly.

SEEING OBJECTIVELY

It was not until the Italian Renaissance, starting in the fourteenth century, that Western artists truly began to draw the figure in this objective way. For prehistoric man, figures were purely representative symbols, little

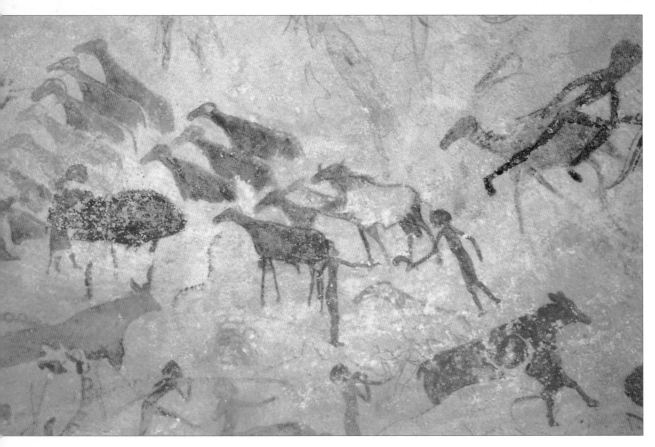

Cave painting at Sefar, Tassili, Algeria
This prehistoric painting shows detailed depictions of herds of animals. In comparison, the human figures look almost stick-like giving a simple representation of the relative importance of the hunters and the hunted.

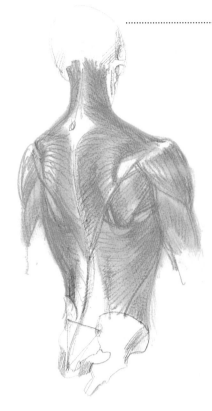

Anatomy

As artists we need to know how the muscles and the deeper structure of the skeleton effect what we see. Thin, surface muscles often reflect other forms underneath. For example, the trapezius, shown here, is a large, triangular muscle which wraps around and reflects the rounded form of the erector muscles of the spine that it overlays.

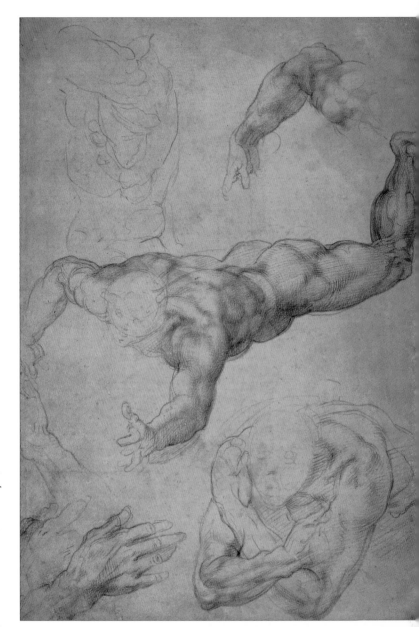

'Studies for a Flying Angel for the Last Judgement' by Michelangelo Buonarroti

Drawing from the live, almost exclusively male, model, Michelangelo made studies of great anatomical verity, with a feeling of vitality and strength never before attained. They are wonderfully expressive evocations of the human form.

more than stick figures. Later, as early societies formed, figures were drawn as gods or spirits. While clearly based on observed human form, they often had special features and emphases, such as a prominent head and eyes to express all-seeing wisdom. In India and the Far East, the tradition of highly stylized depictions of human figures continued for many centuries and to some extent still continues today. By the fifth century BC, Greek sculptors were carving wonderfully life-like, although somewhat idealized, male and female figures.

Taking their cue from the art of Classical civilization, Renaissance artists began to produce truly objective drawings. Artists such as Leonardo da Vinci and Michelangelo learnt to overpower their subjective vision, based on their knowledge of the fundamental principles of perspective and anatomy. In this way they rendered the human form realistically, giving the illusion of depth on a flat surface.

Since the Renaissance, artists working in the West have had the tools, as it were, to draw the human figure objectively. The principles that the Renaissance artists adhered to, the use of perspective, anatomical observation and precise judgement of proportions, are just as relevant today and they are fully covered in this book.

ABOUT THIS BOOK

Before you start to draw, however, you will need to choose a medium. Chapter 1 describes the materials that are particularly suitable for figure drawing and explains the various effects you can achieve with each medium. Almost any medium can be used for figure drawing, but those which allow you to make changes easily and quickly are best to begin with. Charcoal is wonderfully versatile and gives you the chance not only to draw boldly in line but also to render a wide range of tones from silvery greys to strong rich blacks. Pencil is probably the preferred medium for most beginners, and it is still one of my favourites for its ability to depict

both sharp detail and broad sweeps of tone, with or without the addition of watercolour or ink washes. As you acquire more skill and confidence, chalks, pastels, pen and ink, and even felt and ballpoint pens, can all be used effectively on different surfaces. You will soon discover the medium that suits you best.

Chapter 2 explains the basic principles of figure drawing. Beginning with simple outline drawing, the chapter describes how to express the form of the figure by using fundamental drawing techniques, such as drawing around the form. Understanding how to convey the fall of light and the colour values of flesh tones also helps the artist to convey the figure accurately. The basic rules of perspective are also discussed here. For the figure artist there is no need to understand the complicated mathematical system behind linear perspective,

but familiarity with the basics will help you to observe objectively and convert the three-dimensional figure into two dimensions on your paper surface.

Chapter 3 explains how the figure artist can convey the fundamentals of anatomical structure. In a similar way to perspective, it is not necessary to have a detailed knowledge of the subject. However, a little background information helps you to see below the surface and understand how the body pivots, bends and balances, and is of great assistance to the eye in selecting significant forms in what can otherwise be a confusing welter of disconnected shape. Even when drawing clothed figures, if you understand the underlying structure it is easier to show how clothes drape and fold over the form. Both chapters 2 and 3 have simple practice exercises to help you to understand the basic principles.

Chapter 4 suggests a range of projects for further practice and inspiration. It explains how to apply the principles of the first three chapters to the range of classic poses. Clothes, accessories, character and setting are also covered.

Throughout the four chapters, my advice is intended to help you in the actual practice of drawing - there is no substitute for making marks on paper. Do not become disheartened if your drawings do not progress in an orderly fashion from generalized forms to a detailed finish – they very rarely do! You must constantly question whether the drawing is right in its entirety and be ready

Searching with line
Looking for information to help describe the observed shape is the essence of drawing. In this study I used exploratory lines, gradually overlaying them with more correct ones as I felt my way to the final shape. The final lines are distinguishable from the earlier ones by their strength of tone or colour.

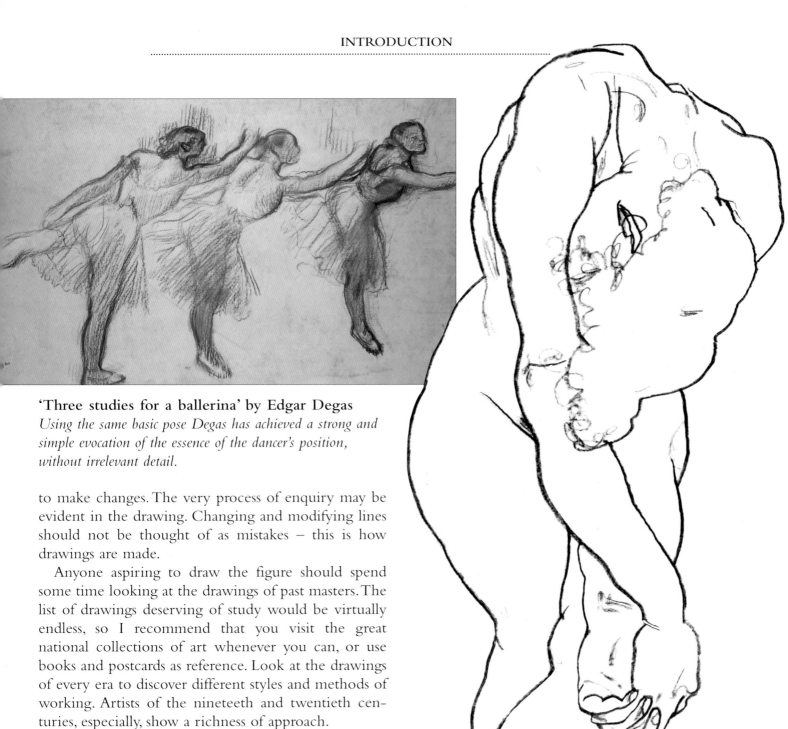

'Three studies for a ballerina' by Edgar Degas
Using the same basic pose Degas has achieved a strong and simple evocation of the essence of the dancer's position, without irrelevant detail.

to make changes. The very process of enquiry may be evident in the drawing. Changing and modifying lines should not be thought of as mistakes – this is how drawings are made.

Anyone aspiring to draw the figure should spend some time looking at the drawings of past masters. The list of drawings deserving of study would be virtually endless, so I recommend that you visit the great national collections of art whenever you can, or use books and postcards as reference. Look at the drawings of every era to discover different styles and methods of working. Artists of the nineteenth and twentieth centuries, especially, show a richness of approach.

The most extraordinary aspect of drawing and painting the human figure is that it is a never-ending voyage of discovery. However long and intensely you pursue the subject, there is always something new to be found, some subtle relationship of forms, a surprising transition from one shape to another. Every person, and every pose, is different. Trying to capture that elusive 'specialness' of every subject you draw is a constant challenge and delight.

Above all you should enjoy yourself. This is in danger of becoming a hackneyed exhortation, but it really is true. Drawing is a struggle, especially figure drawing, but when it goes well it is a great delight for the artist and, by proxy, for the viewer.

'Girl with head bowed' by Egon Schiele
One of my favourite artists of the early twentieth century is Egon Schiele, who produced a large number of superbly expressive, even anguished drawings of himself and his models. Here, he has conveyed the tension in the pose by means of a few simple lines around the outline of the figure.

MATERIALS

CHARCOAL

Charcoal is ideal for both quick sketches and more detailed drawings.
You can use soft sticks for subtle gradations of skin tone and harder types
to add crisp outlines and bring out textures in the hair or clothes.

CHARCOAL HAS BEEN USED as a drawing medium since prehistoric times. The types available to the modern artist are mainly made from sticks of vine and willow. They come in different lengths and thicknesses and can be bought at any good art-supply store. Charcoal also comes in pencil form, which can be sharpened easily for fine line work, and in powdered form (a by-product of stick charcoal), which can be applied by hand or with a stump of torchon paper to build up large areas of tone.

Charcoal is a very versatile medium to work with. You can use it for rapid line sketches of a moving figure, to convey energetic movement. Precise detail can be achieved with the smaller sticks and by using the sharp edge of a newly snapped stick. You can smudge lines and tones with your fingers or with a stump of torchon paper.

This is the charm of charcoal – you can develop and rework a charcoal drawing for as long as you like, as it can be smudged, altered and even completely erased more easily than any other medium. Modifications and erasures can be effected with bread, kneaded erasers and, for sharper and brighter highlights, hard erasers (see *Erasing charcoal*, opposite).

So be bold right from the start, as any mistakes can easily be worked over – but do remember to fix your charcoal drawings with aerosol spray as soon as possible after completion to prevent accidental smudging.

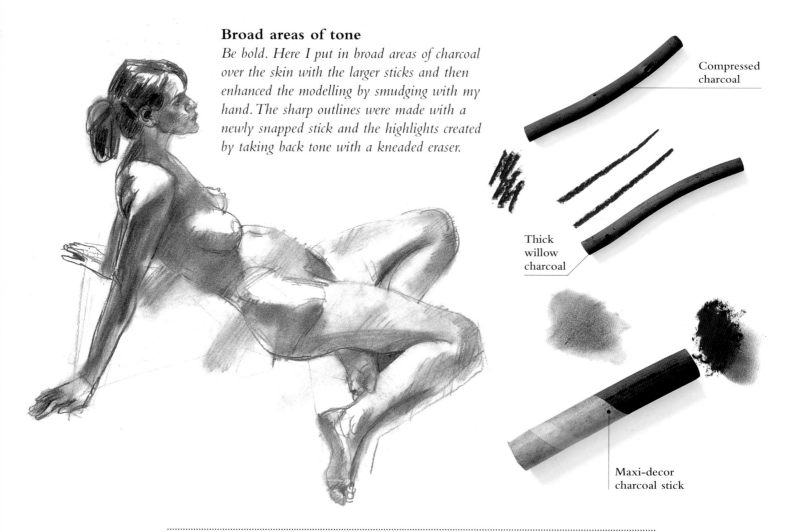

Broad areas of tone
Be bold. Here I put in broad areas of charcoal over the skin with the larger sticks and then enhanced the modelling by smudging with my hand. The sharp outlines were made with a newly snapped stick and the highlights created by taking back tone with a kneaded eraser.

Compressed charcoal

Thick willow charcoal

Maxi-decor charcoal stick

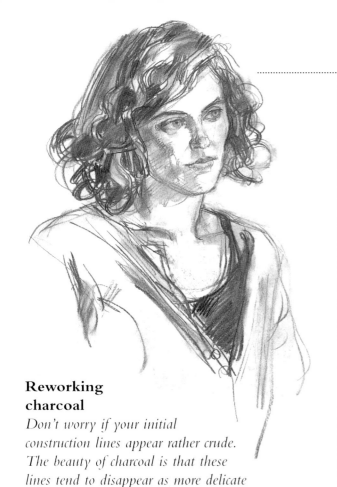

Reworking charcoal

Don't worry if your initial construction lines appear rather crude. The beauty of charcoal is that these lines tend to disappear as more delicate modelling is searched out. Here the change of plane between the shadowed side of the face and the front was first marked by a bold, black line which was softened as the charcoal was worked up.

Charcoal pencil

Erasing charcoal

You can erase areas of a charcoal figure drawing to create angles of light and bring out highlights in dark and shaded areas.

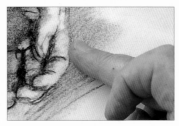

Toning down
Rub the charcoal with your fingers to tone down 'aggressive' darks. Here this creates a uniform area of tone against which the hand stands out.

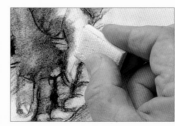

Soft highlights
Use a kneaded eraser to create soft highlights for definition on the hand.

Kneaded eraser

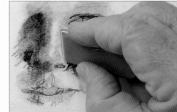

Subtle gradations
Gently rub a stump of torchon paper (or tortillon) to smooth out shading and attain subtle gradations of tone.

Torchon paper

Bold highlights
Rub a hard eraser to create bold, crisp highlights, such as here, along the length of the nose.

Hard eraser

Tonal drawing

To create a dramatic shaded drawing, use thin charcoal for the initial construction lines then quickly progress to larger sticks and broader marks. Here, shadows have been created by rubbing over scribbled areas with my fingers. A kneaded eraser was used to take back the lit areas on the face and hand and to create the more subtle modelling effects, such as the reflected light in the cheek.

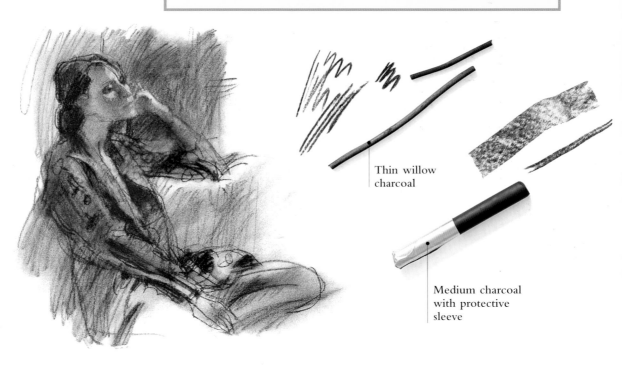

Thin willow charcoal

Medium charcoal with protective sleeve

PENCILS

Graphite pencils make more permanent marks than charcoal, but they still allow you to alter a drawing as you work, either by partial or complete erasure.

ALL GRAPHITE PENCILS consist of more or less standard graphite mixes, but they vary in their degrees of hardness. The hard grades come in a range from H to 9H. The 9H grade is the hardest: it is difficult to erase and, unless you press very forcibly, allows you to make only pale grey lines and tones. The soft grades are marked from B to 9B. The 9B grade is the softest, although it is not easy to find pencils any softer than 6B. HB designates the middle grade.

The soft B grades are rather like charcoal, in that only a relatively light touch is needed to make quite black marks, and they can be erased fairly easily. When using them, begin by holding the pencil very gently in your fingers. As you become more certain, you can gradually increase the pressure, saving the blackest marks for areas that require the most emphasis.

The density of a pencil mark is also highly dependent on the type of surface used. A hard surface gives a much more intense line than soft surfaces: for example, drawing with a 6H on a gesso-coated panel can look similar to a 4B on soft, thick drawing paper. Coloured pencils also offer a good range of effects.

Soft pencil drawing

Drawing with a 5B pencil on rough watercolour paper yields marks that are very rich and black, so a delicate touch is required in the early stages. At the start of this drawing, I held the pencil very gently, almost letting the pencil rest on the paper under its own weight. Applying more pressure at the end allowed me to put in the darkest shading and emphasize parts of the figure's sinuous outline.

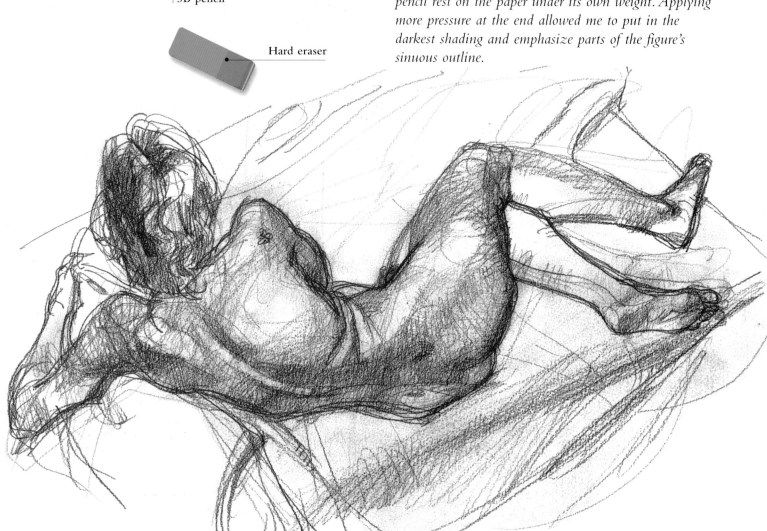

5B pencil

Hard eraser

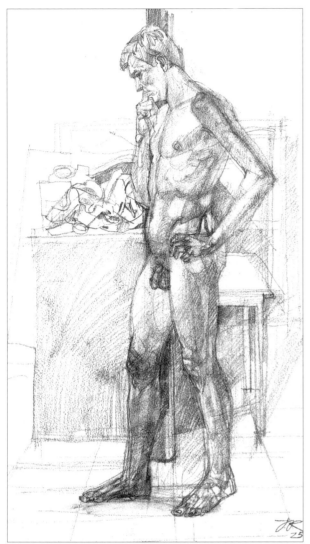

Kneaded eraser

2B pencil

Medium-grade pencil

With a pencil of medium grade (2B), you can work quite precisely – creating a very detailed study of the figure and its environment. Softer shading strokes are also possible: note how the tooth of this semi-rough watercolour paper shows through in the shaded areas.

Coloured pencils

Coloured pencils

Coloured pencils are made of pigmented wax, rather than graphite. They are available in large colour ranges of one hardness grade. You need to press quite hard to make a strong mark, and it is better to draw on a fairly hard, toothed paper.

Different marks

The marks that graphite pencils make depend on the hardness grade, the type of point and the paper surface. Experiment to become familiar with the different effects.

Graphite stick

A graphite stick gives a thick line. On a rough surface, the effect is similar to charcoal but less easy to erase.

Graphite stick

Chisel edge

With a pencil sharpened to a flat chisel edge, you can make fine lines with the tip and broader strokes with the flat side.

Chisel-edged pencil

Gesso ground

Pencil marks appear much blacker when made on a surface coated with plastic gesso primer. With a little water, the marks can be smudged to create areas of tone.

CHALKS & PASTELS

Chalks and pastels are pigment powders bound together with gum or resin. They impart very pure colour which can be used to reproduce skin tones faithfully or, if you want, to exaggerate and dramatize them.

THE DISTINCTION between chalks and pastels is rather vague, but the former are generally considered to be harder and coarser. Both chalks and pastels are available in stick form, the best soft pastels being produced in huge ranges of colours, shades and tints. Contrary to expectation, perhaps, you can't easily erase chalks or pastels – but you can hide marks simply by overdrawing. Colours can also be mixed by hatching or dotting different colours over one another or by blending strokes (see *Mixing pastels*, opposite).

Soft pastels are a particularly versatile medium: the edge of a stick can create a fine line, while the broad end makes a thicker mark with a coarse and crumbly texture. Between hard chalks and soft pastels is the medium generically known as Conté. Originally manufactured by Conté à Paris, it is now available in stick and pencil form. I generally use the sticks only for the earth colours of sanguine and raw umber.

To guard against smudging, drawings made with chalk and pastel – and indeed charcoal – should be protected by spraying with fixative. However, some artists believe that fixing slightly dulls pastel colours, and prefer to tape tracing paper over their drawings or, if they are to be hung, to frame them under glass.

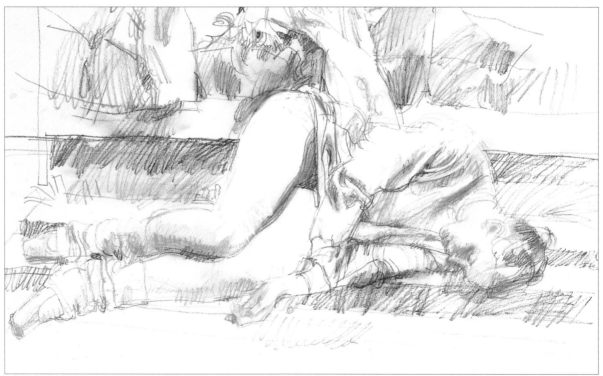

Limited palette of Conté pencils
The addition of one or two colours can greatly enliven a monochromatic drawing. This drawing of a dancer asleep was created in the main with black and grey Conté pencils, but I also used a white Conté stick to emphasize the fall of light on the top of the body and a raw sienna pencil to establish the head and the hands as the focal points of the drawing.

Conté pencils

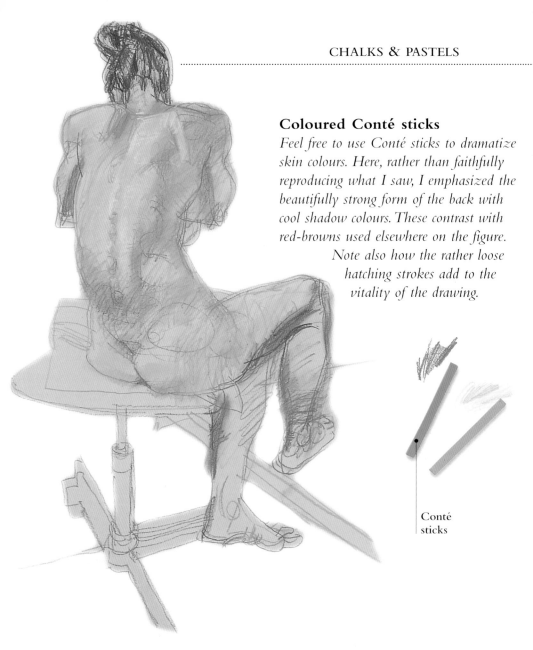

Coloured Conté sticks

Feel free to use Conté sticks to dramatize skin colours. Here, rather than faithfully reproducing what I saw, I emphasized the beautifully strong form of the back with cool shadow colours. These contrast with red-browns used elsewhere on the figure. Note also how the rather loose hatching strokes add to the vitality of the drawing.

Conté sticks

Soft pastels

Using soft pastels is akin to painting with sticks of pigments – you can lay down colour quickly, and easily make modifications by overlaying strokes. I usually use a toned paper or board for soft-pastel drawings. The brown paper here served as an initial middle tone, enabling me to work from both ends of the tonal scale.

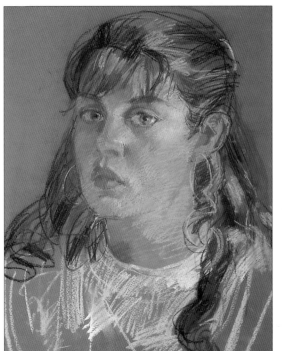

Soft pastels

Mixing pastels

Pastels can be mixed on the paper by blending together thick strokes of solid colour or by crosshatching thinner strokes on top of one another.

Blending colours

Applying two or more colours in solid blocks and then rubbing them together gently with your finger or a paper stub gives you smooth blends of mixed colour.

Crosshatching colours

Crosshatching two different colours over one another creates a third colour in the viewer's eye – a process known as optical mixing. Look at the way yellow over blue here has resulted in green.

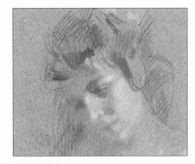

Mixing colour in practice

Both of the mixing methods described above are shown here. Overlaid hatched strokes are used for the hair, while smudging creates blends of colour for the face.

PEN & INK

As every mark is final, pen and ink can be an intimidating medium.
But this also accounts for its charm. A drawing in pen and ink has to be
spontaneous – it works first time or it doesn't work at all.

STRONG PEN AND INK drawings, with flowing, boldly stated lines, are wonderful to behold – but very difficult to achieve. As you cannot erase ink, the medium demands courage and conviction. However, there are ways to build up your confidence.

Firstly, the ink you use need not be waterproof, which means that it can be modified a little by adding water (or saliva). Secondly, take a circumspect approach, mapping the structure of the figure first with little ticks and dots. When you are sure that these exploratory marks are in the right place, you can then confirm them with continuous lines. (This method is employed in the Outline Drawing exercise on pages 32–33.)

Of course, you don't have to stick to line work. You may want to leave some of your stuttering ticks and dots showing to offset the fluid, continuous strokes. To create tonal areas, you can spread non-waterproof ink with your fingers (see *Coloured inks*, below), or use hatching and crosshatching or even close dotting. Dipping your pen alternately into ink and water allows you to vary the tone of your marks. You don't have to use black ink – there are lots of coloured inks available.

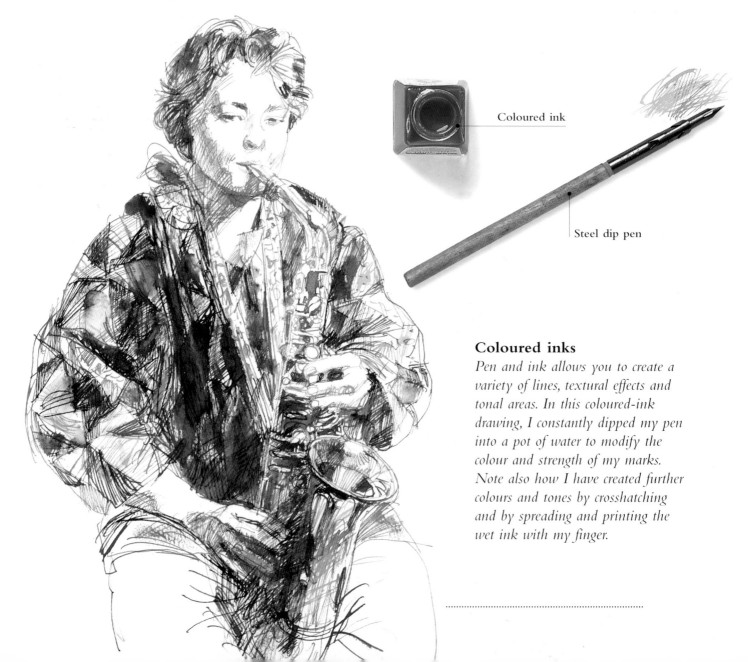

Coloured ink

Steel dip pen

Coloured inks

Pen and ink allows you to create a variety of lines, textural effects and tonal areas. In this coloured-ink drawing, I constantly dipped my pen into a pot of water to modify the colour and strength of my marks. Note also how I have created further colours and tones by crosshatching and by spreading and printing the wet ink with my finger.

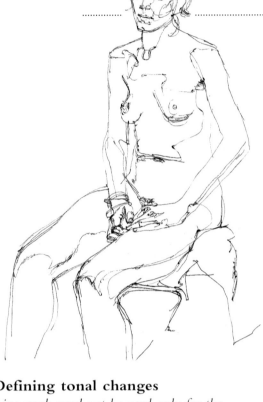

Pen & ink effects

A large range of marks can be made with pen and ink. Experiment with different pens, nibs and papers, as well as trying out the various techniques shown here.

Dotting and ticking

Rather than committing yourself to a continuous line straight away, use a series of small broken marks to 'search' for it.

Broken line

Drawing on a rough-surfaced watercolour paper tends to produce a broken line that helps you to build up descriptive tone in a controlled way.

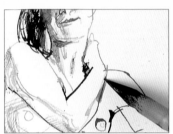

Diluted ink

Dipping a large bamboo pen in ink and water alternately enables you to make broad but pale marks. First test your marks on a spare piece of paper.

Hatching

You can make very subtle tones with pen and ink by hatching or crosshatching. Use a free-flowing pen on a fairly smooth paper for best results.

Defining tonal changes

Line work need not be used only for the outline. Here, I also used line to define where tonal changes occurred. As building up tone with pen and ink is time consuming, this can be a quick and effective way of registering the way the light falls.

Bamboo pen

Indian ink

Building up an outline

Since an ink mark is final, I recommend a cautious approach. Here, I began with thin, delicate lines, and then, where necessary, reworked them with more vigorous, and more accurate, strokes. Note also that some shading on the back has helped to define the form and that a linear pattern describes and 'colours' the hair.

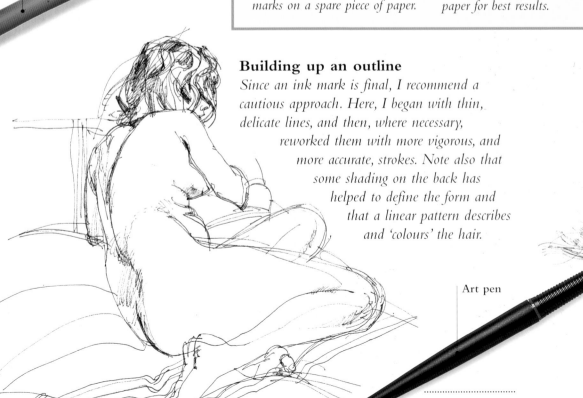

Art pen

LINE & WASH

*While a line drawing has a pure, austere beauty of its own, adding
washes allows you greater freedom in establishing tonal areas
and conveying the fall of light.*

LINE AND WASH drawings allow you to experiment with a large range of media. The line work can be created in almost any medium. Pen and ink is a common choice as it creates striking contrasts between crisp, incisive lines and the soft tonalities of the wash.

For the washes, you can use either water-soluble or waterproof ink. Using the same ink for both line and wash produces a wonderful monochromatic drawing with a subtle range of tones – from the white of the paper surface, through the greys of the washes, to the black of the lines.

Alternatively, use watercolour washes to bring your drawing alive with colour. In the pencil and watercolour study below, I have used rather muted colours, but if your figure is wearing bright clothes, feel free to use stronger hues to make your drawing really 'sing'. Note, though, that if your image is to be considered a drawing, rather than a painting, the washes should not compete with the strength of the line.

After selecting your media, choose a drawing surface that will accept washes. This may necessitate pre-stretching watercolour paper (see page 27).

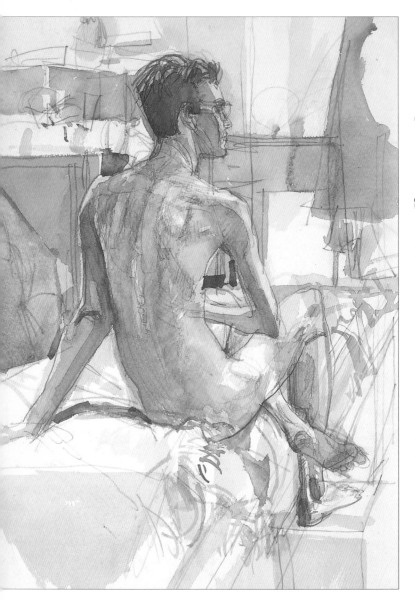

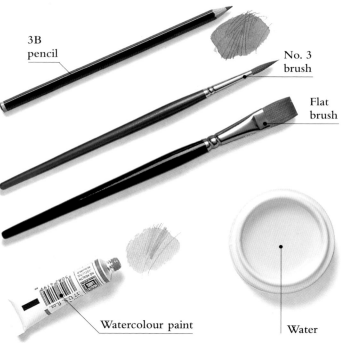

3B pencil

No. 3 brush

Flat brush

Watercolour paint

Water

Pencil and wash

Here, I first completed the pencil drawing with just enough areas of tone to give me some guidance for applying the washes of colour. Always be selective with your washes – don't think you have to cover every inch of the paper with colour. Note the way I've arranged cool blue and purple washes around the warmer colours for the figure and background cupboards at the centre of the drawing.

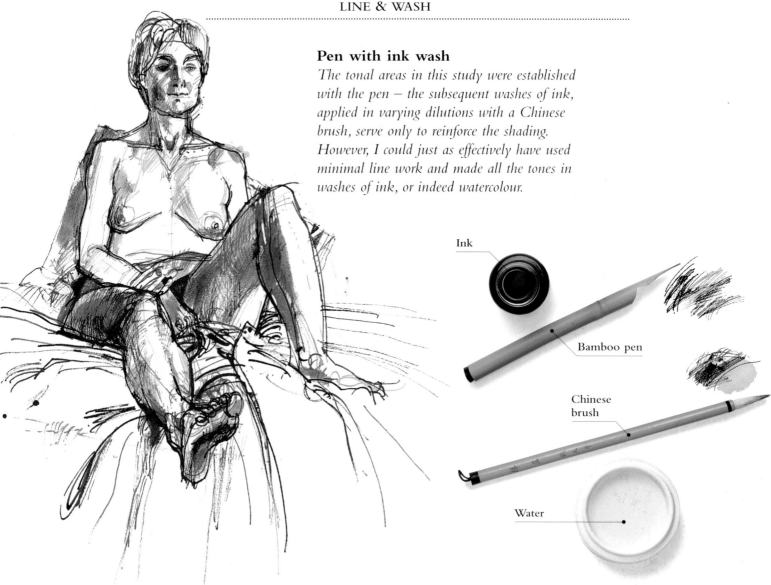

Pen with ink wash

The tonal areas in this study were established with the pen – the subsequent washes of ink, applied in varying dilutions with a Chinese brush, serve only to reinforce the shading. However, I could just as effectively have used minimal line work and made all the tones in washes of ink, or indeed watercolour.

Ink

Bamboo pen

Chinese brush

Water

Working with line and wash

A wash is a pigment mixed with enough water to allow it to flow over the paper surface. The first three illustrations below explain how to lay a flat wash. Also shown are the two basic ways of approaching a line and wash drawing: by either drawing the lines first or applying the washes first.

Laying a flat wash

Line first

Wash first

1 *Use the biggest brush possible in the given space. With the paper tipped slightly down, apply the paint at the top of the wash area and let it flow into a 'pool'.*

2 *Continue the wash by reloading the brush and adding the paint to the pool. Do not apply paint above the pool as this will mar the flatness of the wash.*

3 *Continue the process until you reach the bottom of the wash area. Then squeeze the brush dry and carefully mop up the residue of paint in the pool.*

With water-soluble ink, you can turn line work into washes. Simply apply a little water (or even saliva) to a brush and smudge the ink contained in the line.

Once a wash is dry, you can draw into it with the pen. Working in this way involves some guesswork, as there is no initial line to guide you in the positioning of the washes.

WATERCOLOUR

The great appeal of watercolours is their transparency. By applying several washes on top of each other, you can create subtle, luminous colour that really brings the figure alive.

STRICTLY SPEAKING, the term watercolour includes all paints that are made to be mixed with water. For the purpose of this book, though, I will use the generally accepted meaning – transparent artist's paints specifically marketed as watercolours. This excludes acrylic paints which, although they can initially be mixed with water, become waterproof when dry, and gouache (body colour), which is intended to be used as an opaque paint (see pages 24–25).

The first choice you have to make when acquiring watercolours is whether to buy tubes, which contain semi-liquid paint, or pans, which contain solid blocks of paint. Pans are ideal for painting quicky as each colour is always on hand, ready to be mixed. Good-quality pan colours should be instantly malleable when they come into contact with a water-laden brush. Pans are available in two sizes: half and whole pans.

Tube watercolour paint is better for mixing large washes. The paint is squeezed out in small quantities on to a palette and mixed with water. A disadvantage is that tube paint doesn't resoften readily once it has dried. If you squeeze out too much paint at once you may waste any that remains unused. Whichever you choose, buy the best quality you can afford.

Using a smooth surface

Washes on a smooth, non-absorbent surface, such as the hot-pressed paper used here, tend to float and give the painting an interesting, if somewhat unpredictable, appearance. Since the colour remains very much on the surface of the paper, it is easily washed off – indeed, when overlaying a wash you tend to remove some of the paint beneath.

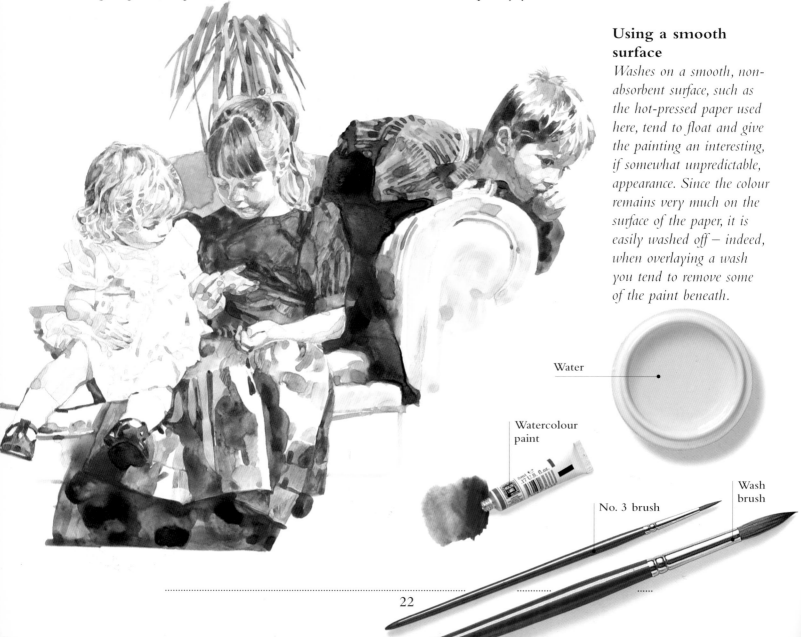

Water

Watercolour paint

No. 3 brush

Wash brush

Creating highlights

Watercolour tones are built up by gradually applying darker washes, but you can create light tones with a thin wash which allows the white of the paper to show through, or regain highlights by one of the methods shown below.

Using masking fluid

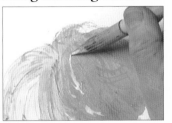

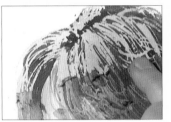

1 *Art masking fluid can be applied with a brush or, as here, with a pen. When dry, it shields the paper from all further washes.*

2 *When the subsequent washes have dried, rub off the masking fluid with your finger to reveal the lighter areas beneath.*

Masking fluid

Swabbing off colour

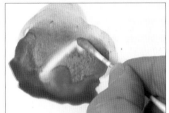

On a smooth surface, swab off wet colour with a rag, a sponge or, as here, a cotton swab.

Cotton swab

Scraping back highlights

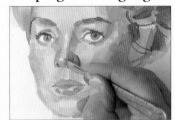

If a vital highlight is lost, you can scrape off dry colour with a scalpel or craft knife – so long as the paper is reasonably robust.

Scalpel

Overlaying washes

Here, I used the classic watercolour method: starting with the lightest colours, allowing them to dry, and then working down towards the darkest shadows by gradually overlaying washes. The darkest tone on the face, by the side of the nose, is the result of three layers: a very light initial wash and then two darker ones made with raw and burnt sienna.

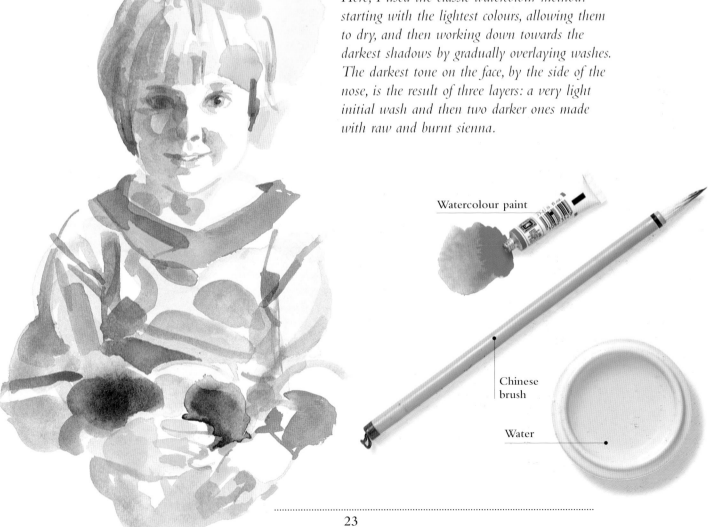

Watercolour paint

Chinese brush

Water

BODY COLOUR

A flexible and forgiving medium, body colour allows you to incorporate painterly effects in your drawings. You can describe the figure and its environment with bold, opaque lights, strong areas of colour, and even exciting texture effects.

IN WATERCOLOURS, you control the tone of the colours by varying the amount of the water in your washes: the more water you add, the more white paper shows through the wash, and thus the lighter the colour. If, however, you lighten a colour by adding white to it, you have moved from watercolour to body colour. Importantly, the white also makes the colour more opaque. As a result, when working in body colour you can overpaint lighter colours on darker ones, build up texture, and create broken colour effects (see *Building up colour and texture*, opposite).

The paint needed for body colour is usually known as gouache. It is sold in tubes or bottles. In good ranges, most of the colours, especially the darker ones, are transparent; I feel strongly that it should be left to the artist to add white to create opaque tints. If colours already contain white, you cannot contrast opaque with transparent areas, which is one of the delights of painting in gouache.

The classic method of using gouache is often called 'thin to fat'. It involves first laying in the darker colours in thin transparent washes, then adding lighter areas with thick (fat) and opaque paint. The thin, dark passages tend to recede and be read as shadow, while the thick, pale areas really stand out as their slightly three-dimensional surface catches more ambient light.

Squirrel brush

No. 6 brush

No. 3 brush

Water

Gouache paint

Opaque colour

Body colour encourages a bold approach. Here I went straight into the drawing with a brush, safe in the knowledge that all the marks could be modified by overpainting with more opaque paint. In this image, I completely redrew the model's right leg, cutting into the inside of it with opaque white paint and then extending it with dark paint on the outside.

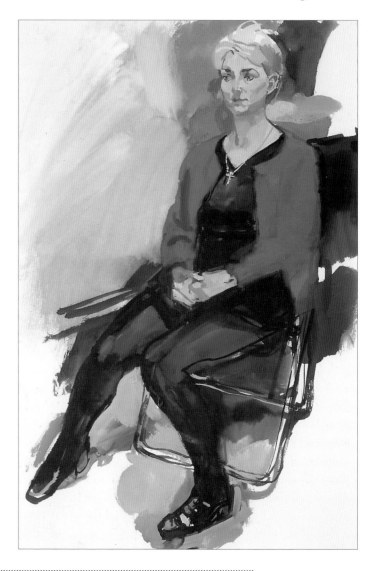

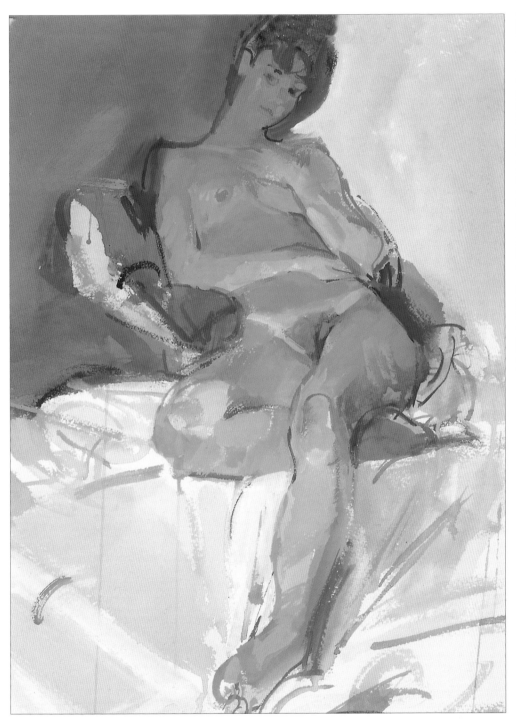

Building up colour and texture

Body colour gives you the chance to explore some of the techniques of oil painting without having to deal with slow-drying paint and special mediums.

Impasto
Applying paint with a palette knife gives a rough texture known as impasto.

Palette knife

Scumbling
Dragging paint unevenly over underlying layers creates broken colour effects, known as scumbling.

Square-edged brush

Oil bar
Oil bar is another body colour that can be applied to paper. When spread with a rag, it dries instantly.

Oil bar

Combining opacity with transparency

One of the delights of using gouache is the ability to combine transparent washes with opaque areas of paint. After mapping out the shape of the figure and the bed with linear brushwork, I established the dark tones in thin washes of raw and burnt sienna. These contrast well with the lighter tones that I added last with more opaque paint.

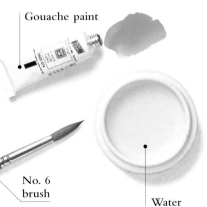

Gouache paint

No. 6 brush

Water

PAPER

Nowadays there is a bewilderingly large variety of papers for artists. For the best results, you need to select a surface that suits your chosen medium.

DRAWING PAPER is the workhorse of papers. It is cheap, universally available, and will take almost any medium. I use it for much of my pencil, pen and ink, and charcoal drawing but, if it is thick enough, it can also work well with watercolour, gouache, and even oil paint. Pastel papers are slightly harder than drawing paper, with a little more 'tooth', which helps to hold the pigment particles in place. From the wide variety of pastel papers available, my preference is for the delicately ridged Ingres paper.

Watercolour papers were once all hand made, but now most are manufactured by machine with wood pulp instead of pure linen rag. Even so, they are generally rather expensive. They come in different surfaces (see *Watercolour paper*, right) and weights. The weight of a paper is expressed in either pounds (per ream) or grams (per square metre). A 300 lb (640 gsm) paper is very thick and will usually accept watercolour washes without buckling or 'cockling'. Thinner papers, though, need to be stretched (see *Stretching paper*, opposite).

The right paper for the right medium

Here I have matched up four different types of surface to suitable media, and also shown the sort of mark you can expect to attain. Note that this is not an absolutely definitive guide: gesso-coated board, for instance, will take almost any medium.

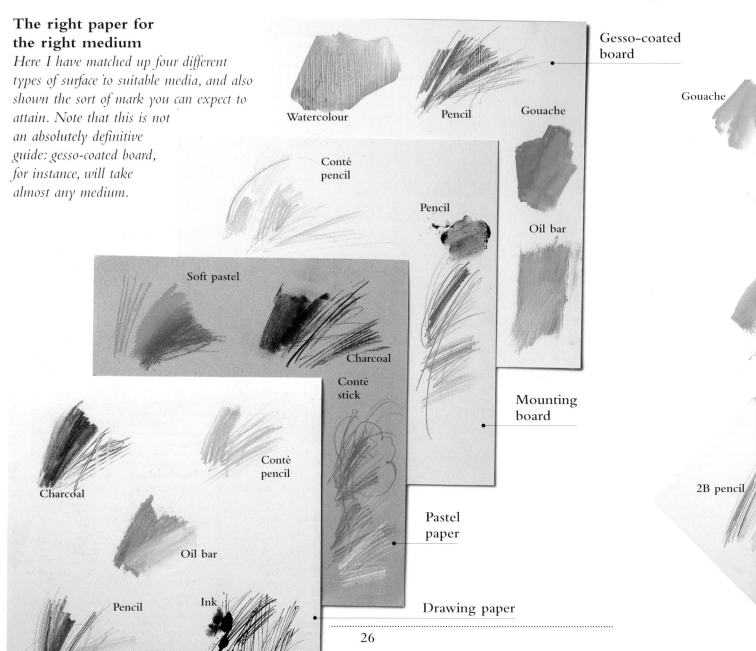

Watercolour

Pencil

Gouache

Gesso-coated board

Gouache

Conté pencil

Pencil

Oil bar

Soft pastel

Charcoal

Conté stick

Oil bar

Mounting board

Charcoal

Conté pencil

Pastel paper

2B pencil

Pencil

Ink

Drawing paper

Watercolour paper

Watercolour papers come in a choice of three surfaces: rough, medium (often called NOT or cold-pressed) and smooth (often called hot-pressed). Although they are primarily intended for washes, watercolour papers are all good to draw on with pen or pencil – even charcoal. You generally attain darker marks on the rougher papers. Semi-rough paper is the most versatile surface, accepting a wide variety of media. With watercolours, it provides a good surface for a flat wash and has enough texture to give a lively finish.

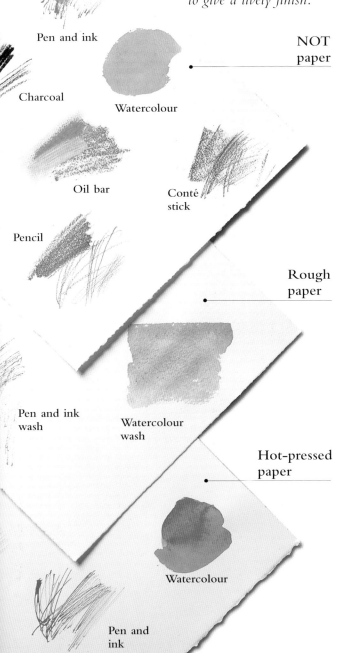

Pen and ink

Charcoal

Watercolour

NOT paper

Oil bar

Conté stick

Pencil

Rough paper

Pen and ink wash

Watercolour wash

Hot-pressed paper

Watercolour

Pen and ink

Stretching paper

Watery washes of paint cause lightweight watercolour papers to buckle or 'cockle'. To ensure your paper remains flat, you need to stretch it, as shown below. It is good practice to stretch heavy papers, too, as they can also cockle.

1 *Wet the underside of the paper thoroughly with a sponge soaked in clean water. Let the paper absorb the water for at least five minutes, or longer for heavy papers.*

2 *While waiting for the paper to swell, cut four pieces of gummed strip to the length of the four sides of your paper. Then dampen the first of these pieces.*

3 *Turn the paper dry side up on to a rigid board, and tape it down. Make sure that all four pieces of tape are securely stuck to both paper and board.*

4 *Don't worry if the paper appears slightly cockled shortly after being stuck down. It will flatten as it dries and will stay that way, even when washes are applied.*

Extra hints

Pinning
As the paper dries it will shrink. This may cause the taped edges to come loose, so pinning the corners provides extra security.

Pins

Stapling
For extra security, staple the edges of the paper to the board at frequent intervals.

Staple gun

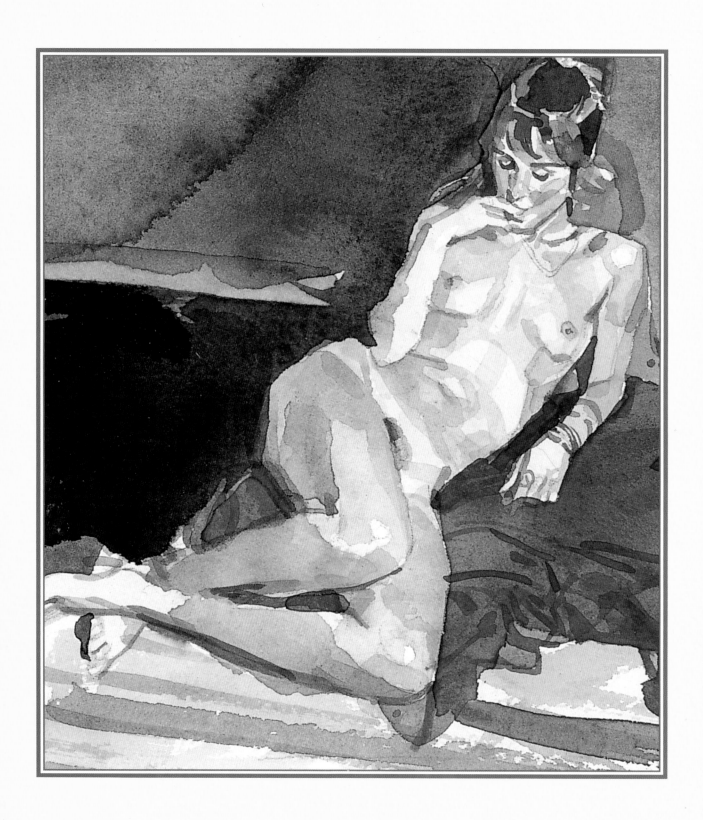

FUNDAMENTAL PRINCIPLES

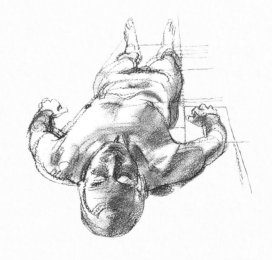

OUTLINE DRAWING

An outline is not simply a way of differentiating a figure from its background. A skilful artist can also use it to suggest the form of a figure and even to hint at how the different parts of the body interlock.

WHEN SUFFICIENT LIGHT is available, we are able to distinguish one object from another – a figure from its background – by changes of tone or colour. By virtue of our binocular vision, we can also see depth. This allows us to sense the volume of a three-dimensional object and to 'read' how its surface turns away and out of sight at the edges. We cannot reproduce this depth in a drawing, but we can give an illusion of depth and volume by various means.

One of these is the use of an outline. A mechanically drawn 'line around' a figure does not tell us much about the volume that is contained by it. But by breaking up the outline, and allowing lines to cross each other, it is possible to give an impression of solidity. In the human figure, we can even begin to suggest how one part of the body links into the next.

Of course, in real life figures do not have visible lines around them at all. An outline is only a drawing convention. Humans have learnt how to 'see' a figure in the symbolic surrounding line. This ability is unique to humans: animals show no sign of being able to recognize simple line images.

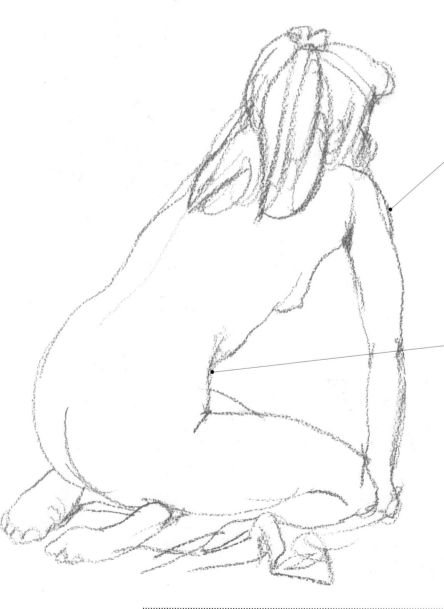

Here, I have drawn two lines around the shoulder. This was not a mistake, but an almost unconscious reaction to the way that the back upper arm (triceps) 'slots' into the shoulder (deltoid). The double lines give a sense of one form swelling in front of another.

Let your pencil over-run a little to indicate overlapping forms. Here, I have partly obscured the model's breast to suggest the form of the back. I also extended the rather imprecise line that defines her hip to show the way it swells out from her waist.

Breaking up an outline

Although this appears to be a simple sanguine chalk drawing, look at the ways I've deviated from a rigid, continuous outline. Firstly, I have drawn several vigorous strokes to indicate the main direction and bulk of the model's hair. To give an impression of the volume of her body, I drew several lines that cut across other lines and bite into the outline. Sometimes a form pushes into, and dents, another form, such as the model's right heel. This is indicated by a stronger line for the heel and a break in the line of the thigh.

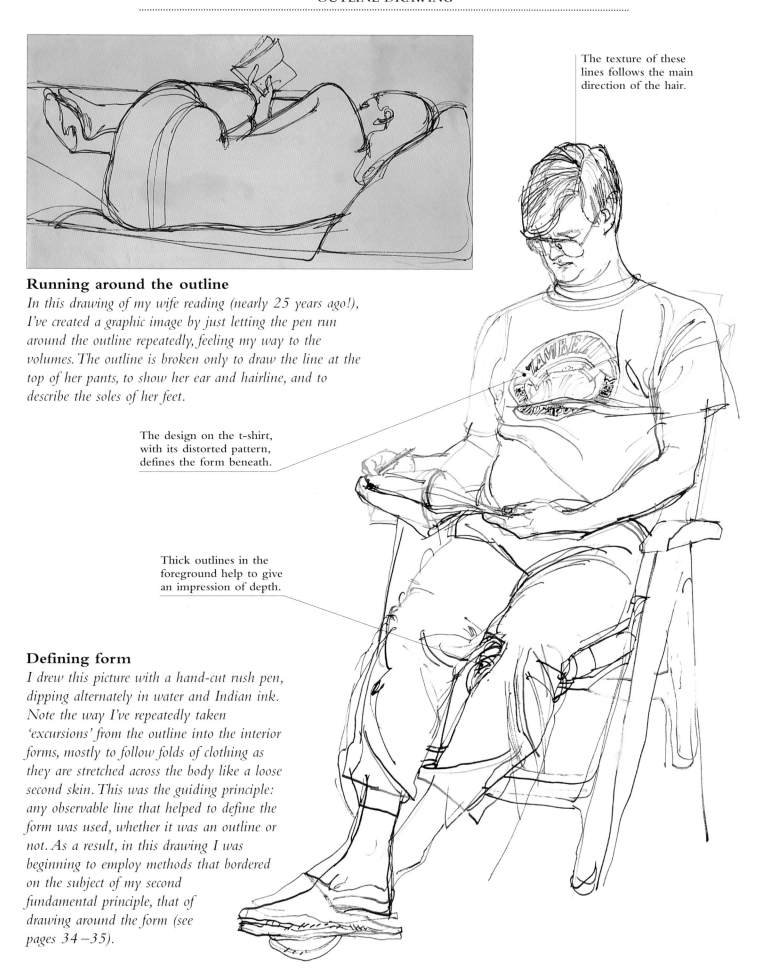

The texture of these lines follows the main direction of the hair.

Running around the outline

In this drawing of my wife reading (nearly 25 years ago!), I've created a graphic image by just letting the pen run around the outline repeatedly, feeling my way to the volumes. The outline is broken only to draw the line at the top of her pants, to show her ear and hairline, and to describe the soles of her feet.

The design on the t-shirt, with its distorted pattern, defines the form beneath.

Thick outlines in the foreground help to give an impression of depth.

Defining form

I drew this picture with a hand-cut rush pen, dipping alternately in water and Indian ink. Note the way I've repeatedly taken 'excursions' from the outline into the interior forms, mostly to follow folds of clothing as they are stretched across the body like a loose second skin. This was the guiding principle: any observable line that helped to define the form was used, whether it was an outline or not. As a result, in this drawing I was beginning to employ methods that bordered on the subject of my second fundamental principle, that of drawing around the form (see pages 34–35).

PRACTICE EXERCISE

TRY TO COMPLETE THIS exercise using only outline and without representing light and shade. You may use lines to indicate some of the inner edges, such as folds of skin or the apertures of eyes, nose and mouth, but concentrate mostly on the outer edges. Make sure your model is lit fairly evenly. Strong contrasts of light and shade within the figure tend to lead you away from the edges.

As far as your choice of drawing medium is concerned, I suggest that you use pen and ink. This is the most unforgivingly linear medium, and therefore limits the temptation to use shading. But note that marks made with a pen are permanent, so start cautiously. Begin with just dots or ticks. Join them up into lines only when you are sure that they are in the right place.

MATERIALS

Art pen

No. 2 brush

Indian ink

White gouache

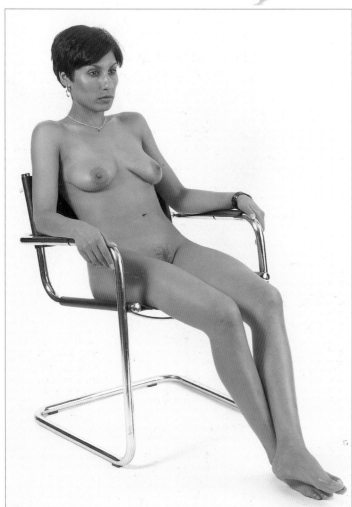

Selected pose

This chrome-tube chair provided a sort of three-dimensional grid that I could use as a guide to positioning the model. A light, plain background made both the model and the chair stand out, helping me to concentrate on their outlines.

1 *Marks made with pen and ink are permanent, so unless you are going for a quick, spontaneous (and risky) drawing, make early explorations with either very watery ink or, as I have used here, tentative ticks and dots.*

2 *To help you attain accurate proportions, work outwards from the centre. In this way, your eye is compelled to scan the drawing from side to side and from top to bottom. If you draw from end to end, you risk the figure tending to grow or diminish.*

3 *Join up lines of dots and ticks when they seem to be in the right place. Proceed with caution, though, at this early stage: remember that for this exercise you have only outline to tell all. Begin to tick in the structure of the chair.*

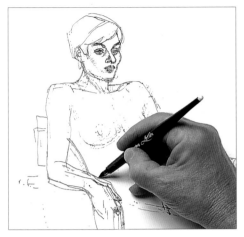 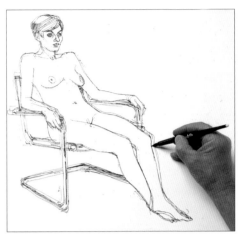 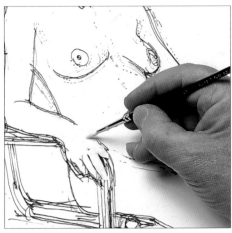

4 *Readjust some of the edges, such as here on the forearm, with new continuous lines. A certain amount of redrawing is acceptable, and may often add life to the image.*

5 *Now confirm the outline of the chair by letting your pen repeatedly run around its tubular form. Also look out for other lines that need refining, such as here on the model's left leg.*

6 *If your revisions look confusing, blank out some of the lines with white paint. Gouache hides ink well, but is difficult to draw over. Liquid paper is better if applied smoothly.*

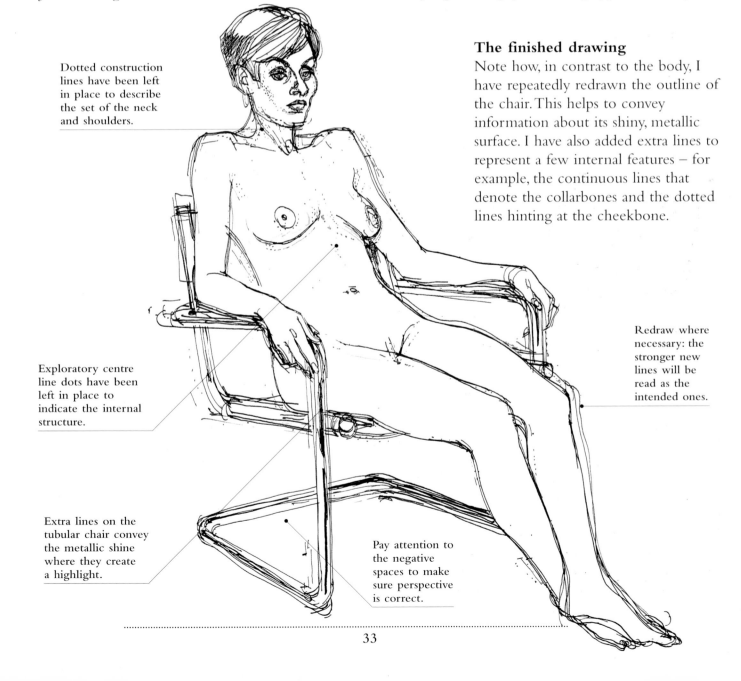

Dotted construction lines have been left in place to describe the set of the neck and shoulders.

Exploratory centre line dots have been left in place to indicate the internal structure.

Extra lines on the tubular chair convey the metallic shine where they create a highlight.

Pay attention to the negative spaces to make sure perspective is correct.

The finished drawing

Note how, in contrast to the body, I have repeatedly redrawn the outline of the chair. This helps to convey information about its shiny, metallic surface. I have also added extra lines to represent a few internal features – for example, the continuous lines that denote the collarbones and the dotted lines hinting at the cheekbone.

Redraw where necessary: the stronger new lines will be read as the intended ones.

DRAWING AROUND THE FORM

An outline can only reveal so much about the interior forms of a figure. For a stronger impression of solidity, move inside the edges to show the volume of the body's surfaces. This involves using line or tone.

DRAWING IS ABOUT conveying information. It is about describing what you see as directly and succinctly as possible. Any means to this end is therefore permissible.

Just as we have accepted the concept of drawing lines where none exist to show the edges of the figure, it is equally admissible to use lines to indicate where the main changes of plane occur or even to draw contours as on a map. This is called drawing around the form. It allows you to go beyond outline drawing and show how the interior forms of the body interlock.

Not quite the same, but performing a similar function, is the addition of tone in places where it is not actually present, in order to show the form more positively. Often you can clearly see a strong change of plane which the given lighting does not emphatically reveal. You should feel free to put in an area of tone to make it as clearly visible in your two-dimensional drawing as it is in your three-dimensional vision.

In short, you need to make sure that the existing lighting does not restrict you. After all, the lighting can change, but the form remains the same.

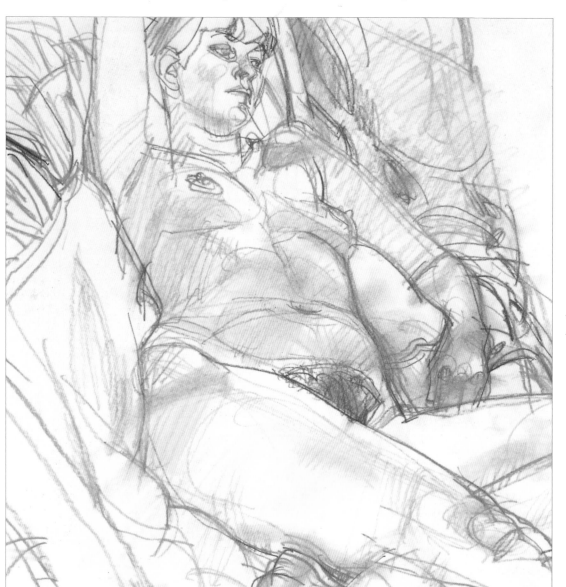

Following the form
This drawing shows the use of line to represent form without resorting to full use of light and shade. True, there are some areas of tone, but they are not dominant. I have used lines not just to define the outline but also to follow the form. Look at the lines around the chin and the left wrist as well as those over the stomach, chest and thighs. None of these lines exists in reality, but they help to clarify the volume that I have observed.

Looking beyond the lighting

Some of the tone in this drawing (far right) is as it appeared on the model, as you can see from the photograph. Much of it, however, was invented or exaggerated in order to clarify the volume of the figure better. For instance, I drew some lines right across the top of her back — their function is simply to reveal form. They trace a path over the model's left shoulder blade, then dip into the ridge of the spine, rise again over her right shoulder blade, and finally slide down her right upper arm.

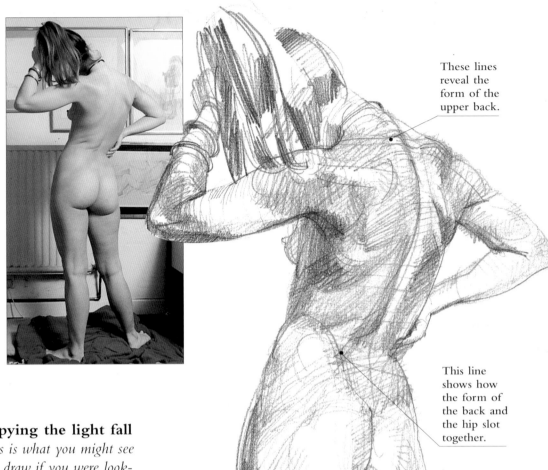

These lines reveal the form of the upper back.

This line shows how the form of the back and the hip slot together.

The interlocking form of the calf muscles behind the knee.

Copying the light fall

This is what you might see and draw if you were look-ing at only the most obvious light-fall on the body. A good deal of the form of the undifferentiated lit area can be inferred, but there is insufficient information for this drawing to serve as a study for a fully worked-up painting or a sculpture.

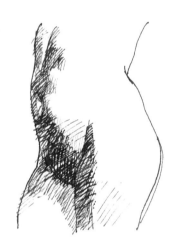

Expressing the form

Now I have drawn into the lit area, inventing tone that is not actually there, to better express the three dimensions that I can see to exist. The rounded form of the hips is now apparent, and the modelling on the stomach is much improved. You could do this with charcoal or pencil just as easily as with pen and ink.

PRACTICE EXERCISE

THE AIM OF THIS EXERCISE is quite simple: to emphasize three-dimensional form. To this end, you need to observe the direction of every plane in your model and to show just how these planes turn and fit together to become the solid figure in front of you. You will need fairly flat lighting conditions. Deep shadows create too much contrast for the subtlety of this exercise. You should use light and shade, or any other drawing method, to help to depict the form that you see.

Imagine that you are producing a working drawing for a sculpture. Sculptors need to know not simply how light falls on the figure, but also exactly where everything is, in depth. In fact, they would need drawings from several different viewpoints to complete their knowledge of the three dimensions of the figure. For further practice you could complete such a series, always attempting to convey information about the volume of the body, rather than simply copying.

MATERIALS

| 2B clutch pencil

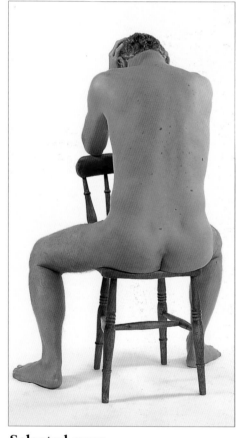

Selected pose
A view of the back is ideal, as it is relatively flat, so you must observe and analyze very carefully to bring out its three-dimensional form. Make sure the model is evenly lit. With little form-revealing contrast, you cannot then simply copy the light and shade to give an impression of solidity.

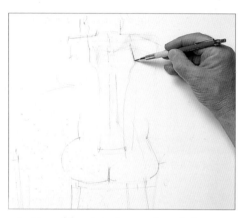

1 Roughly plot the stool and the outline of the body. Then begin to mark the main changes of plane in the back, using firm, definite lines. In particular, make sure you record the 'valley' of the spine and, as here, the protuberance of the shoulder blade.

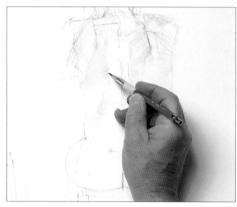

2 Now indicate the planes themselves by using loose hatching strokes. The left-hand side of the back is turned away from the light, but you can still see changes of plane here. Begin to indicate these by altering the strength of the hatching.

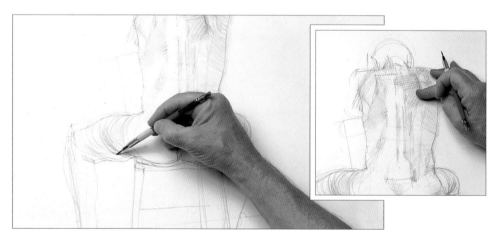

3 The left leg, like the left side of the back, has very little form-revealing light on it. To bring out its rounded form, you need to use contour lines. Let your pencil run round the left leg as though you were drawing a series of strings tied around it, or even imaginary lines actually marked on the skin. Inset: Avoid using an eraser – it is better to take back strong marks with your finger and then redraw.

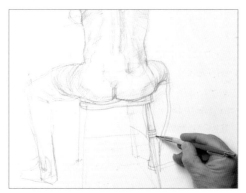

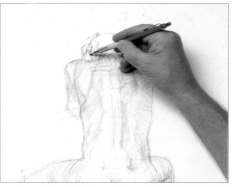

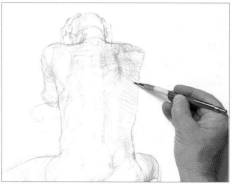

4 *Lightly plot the hexagonal shape where the four legs of the chair and the two feet meet on the floor. Then you can work up the chair legs with much more confidence.*

5 *I left the head almost until last, which is not usually good practice. In this pose, however, I considered it better to first put in the arms and hands that support the head.*

6 *Although the right-hand side of the back is actually receiving light, I have invented a tone to show more clearly how it falls away from the 'high ground' of the centre back.*

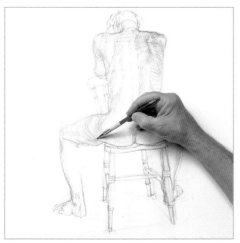

7 *In the final stages, concentrate on the drawing itself rather than on the model. Check whether you can read all the changes of plane, and that the 'landscape' of forms looks complete. Here, I emphasized the cylindrical form of the left leg.*

The finished drawing

Throughout this drawing, I tried to keep my judgement of form and depth independent of my observation of light and shade. Compare the final drawing with the photograph on the opposite page. You can see that although the top right side of the back is catching light, I have nevertheless used a strong tone to describe how the form turns away.

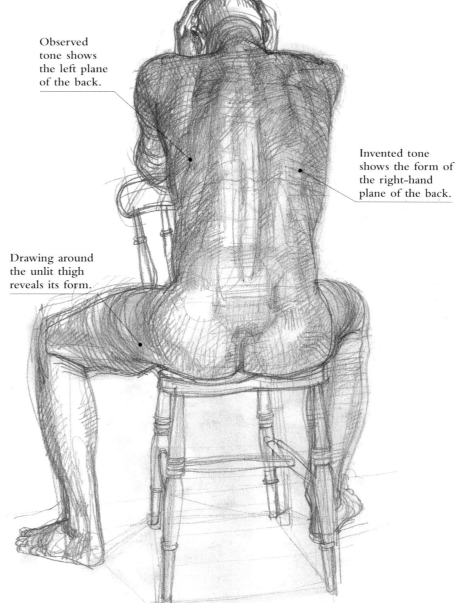

Observed tone shows the left plane of the back.

Invented tone shows the form of the right-hand plane of the back.

Drawing around the unlit thigh reveals its form.

LIGHT & SHADE

Even if we were totally blind to colour, the fall of light would enable us to see and interpret the world quite satisfactorily. Figure artists can use light and shade to enhance the illusion of solidity or just add vitality and drama.

LIKE THE TECHNIQUE of drawing around the form, describing light and shade can give an object an impression of solidity. Most beginners believe this is done by noting the gradual transition of tone from the lit to the dark side. In fact, there is often an identifiable line which shows just where the form turns away from the light and into shadow. On rounded objects it tends to be blurred and broad. By exactly following its outline and defining the outer shape of the object, the form and volume will be made evident, even with little or no change of tone between the lit and shaded sides.

In diffused or low light conditions it may not be possible to define this demarcation line so precisely, in which case you may have to look for softer gradations. The figure may be illuminated in many different ways, from behind, in front, above or below. Each lighting situation has its own pattern of light and shade, and although it may not be strictly necessary to use it all to depict the form, areas of tone are interesting in their own right. It is perfectly acceptable to make description of light and shade the primary subject of your drawing.

Describing volume

To give a convincing impression of the solidity of a form, such as this strongly illuminated apple, first locate the demarcation line which shows where the form turns out of the light and into shadow. The cast shadow of the stalk provides a useful confirmation of the form.

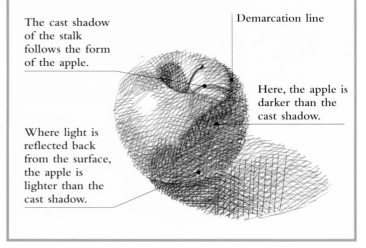

The cast shadow of the stalk follows the form of the apple.

Demarcation line

Here, the apple is darker than the cast shadow.

Where light is reflected back from the surface, the apple is lighter than the cast shadow.

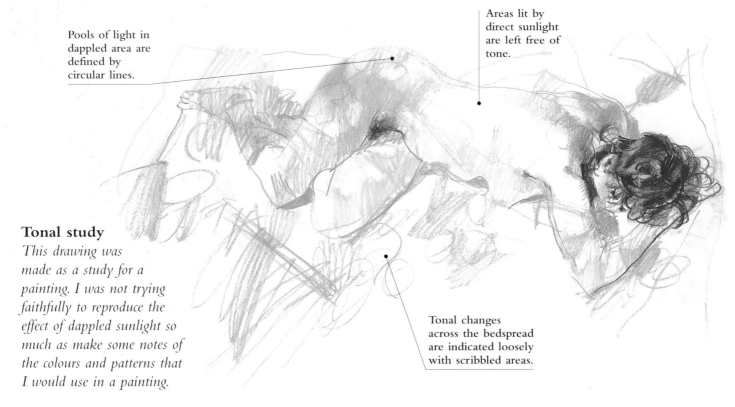

Pools of light in dappled area are defined by circular lines.

Areas lit by direct sunlight are left free of tone.

Tonal study
This drawing was made as a study for a painting. I was not trying faithfully to reproduce the effect of dappled sunlight so much as make some notes of the colours and patterns that I would use in a painting.

Tonal changes across the bedspread are indicated loosely with scribbled areas.

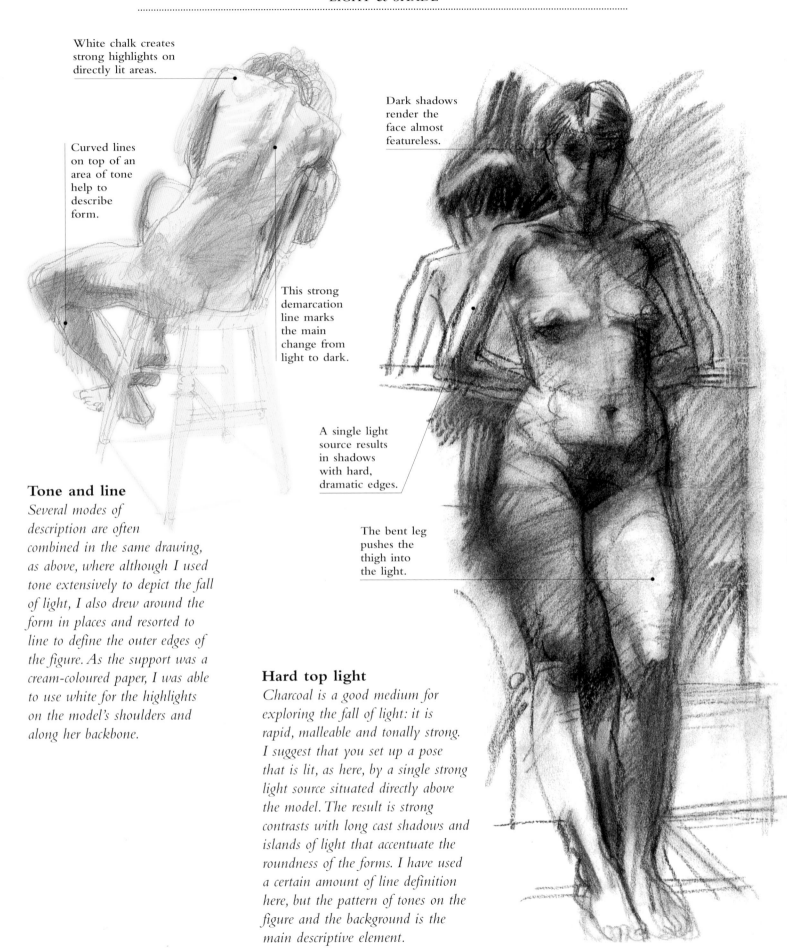

White chalk creates strong highlights on directly lit areas.

Curved lines on top of an area of tone help to describe form.

Dark shadows render the face almost featureless.

This strong demarcation line marks the main change from light to dark.

A single light source results in shadows with hard, dramatic edges.

The bent leg pushes the thigh into the light.

Tone and line

Several modes of description are often combined in the same drawing, as above, where although I used tone extensively to depict the fall of light, I also drew around the form in places and resorted to line to define the outer edges of the figure. As the support was a cream-coloured paper, I was able to use white for the highlights on the model's shoulders and along her backbone.

Hard top light

Charcoal is a good medium for exploring the fall of light: it is rapid, malleable and tonally strong. I suggest that you set up a pose that is lit, as here, by a single strong light source situated directly above the model. The result is strong contrasts with long cast shadows and islands of light that accentuate the roundness of the forms. I have used a certain amount of line definition here, but the pattern of tones on the figure and the background is the main descriptive element.

PRACTICE EXERCISE

THE DEPICTION OF light and shade – without recourse to line or drawing around the form – is the nearest that painting or drawing comes to a photographic record. This is not to say that you should simply reproduce a photograph when drawing by this method. As always, it is best to work from a live model. You can then decide how the tonal range can be simplified to convey the essence of the pose. In low light, for instance, the outline of parts of the figure may barely be distinguishable from the background, and you could exaggerate this by losing the edge completely, allowing the viewer to infer what is missing. Conversely, you may want to enhance an area of contrast. This seems to happen in reality: the eye exaggerates the contrast between adjacent lights and darks. Examples of both effects appear in this image. I have lost the outline of the lower legs against the bed cover, and yet I have darkened the left knee to increase the contrast with the light wall.

MATERIALS

Chinese brush

No. 2 brush

Selection of gouache paints

Water

1 *Working quickly with wet, loose washes of grey and black, establish the main tonal areas. At this early stage, it is better to make the tones lighter than they actually appear.*

2 *Next, introduce some darker tones, especially for the blanket. Note that at this stage I have described the shape of the figure negatively, by working up the blanket around it.*

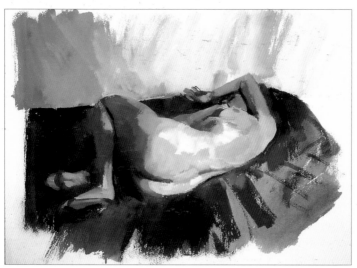

3 *Next, I introduced white to my mixes and established two basic tones in the light areas of the model's torso. With a black and grey mix, I made the lower legs almost as dark as the blanket. I also started on the graduated grey wash in the background.*

4 *As you study your subject in terms of tone, you may discover that even in the lightest areas there is considerable variation, only the very brightest highlight meriting a straight white. Remember, the brightest highlight is not always on the figure; it may be on the background. Every tone must be ruthlessly assessed against every other one.*

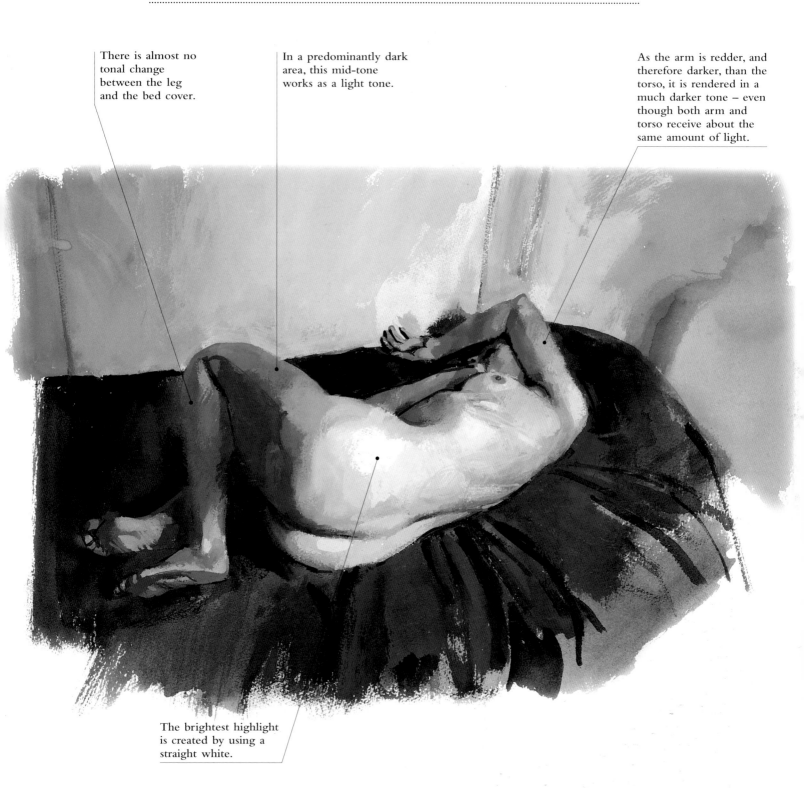

There is almost no tonal change between the leg and the bed cover.

In a predominantly dark area, this mid-tone works as a light tone.

As the arm is redder, and therefore darker, than the torso, it is rendered in a much darker tone – even though both arm and torso receive about the same amount of light.

The brightest highlight is created by using a straight white.

The finished painting

As the fundamental principle of this exercise was the depiction of fall of light, I completed the painting in monochrome. This allowed me to concentrate on the tonal range without the distraction of colour. When rendering light and shade, remember to take account of the local tone of your subject matter as well as the effect of the light. For instance, in this painting the model's arms are much darker than the torso, even though they were both receiving the same amount of light. I painted them as a darker tone because her arms were redder, and therefore darker, than the pearly flesh tones of her torso, highlighted in white. In other words, a dark colour – even in bright light – will remain dark.

COLOUR

*When painting the human body, attaining the right flesh colours is
often considered the most difficult task. The secret, as ever, is close observation.
Believe in your eyes, not in what you think you know.*

PROBABLY THE MOST popular question about colour asked in relation to figure drawing is 'How do I mix flesh colour?' There is no simple answer, unless it is that there is no such thing as flesh colour.

Manufacturers sell what is known as flesh tone in a tube, a sort of Naples-yellow-with-a-hint-of-vermilion, but do not be persuaded by it. It is hopelessly inadequate to deal with all the infinitesimal variations of colour of the human body.

The colour of flesh, like every other observable object, depends on both its inherent colour, often called local colour, and on the colour of the light that illuminates it. Both of these vary enormously.

There are great differences, for instance, in the local colours of the face. For fair-skinned people, the colour of cheeks and ears, where the blood vessels are close to the skin's surface, appear much redder than, say, the forehead or chin. On the body itself, the hands, feet, elbows

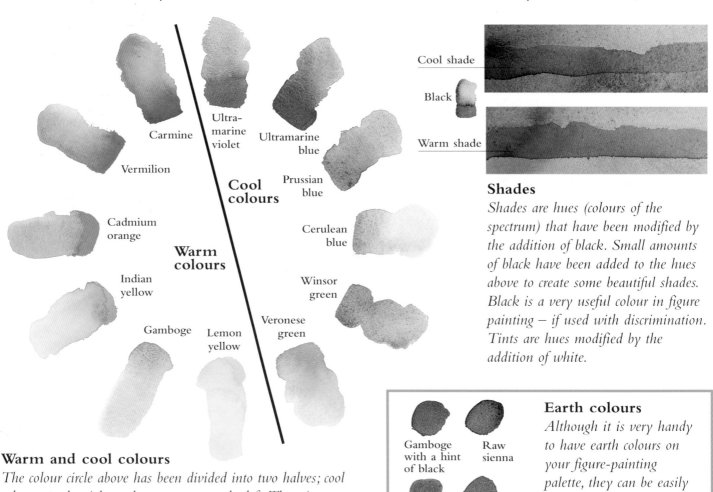

Carmine

Vermilion

Cadmium
orange

Indian
yellow

Gamboge

Lemon
yellow

Ultra-
marine
violet

Ultramarine
blue

Prussian
blue

Cerulean
blue

Winsor
green

Veronese
green

**Cool
colours**

**Warm
colours**

Cool shade

Black

Warm shade

Shades
*Shades are hues (colours of the
spectrum) that have been modified by
the addition of black. Small amounts
of black have been added to the hues
above to create some beautiful shades.
Black is a very useful colour in figure
painting – if used with discrimination.
Tints are hues modified by the
addition of white.*

Warm and cool colours
*The colour circle above has been divided into two halves; cool
colours on the right and warm ones on the left. There is
some doubt about the temperature of colours just on the
dividing line – lemon yellow only has to be a little greener
for it to become a yellow-green, and therefore closer to the
cool side of the line. When painting flesh, don't just use the
warmer colours, the yellows, oranges, reds and pinks. The
cooler colours are also important – look at the shadow tones
on the underside of the body (see* Using black, *opposite).*

Gamboge
with a hint
of black

Raw
sienna

Vermilion,
orange and
black

Burnt
umber

Orange
and black

Burnt
sienna

Earth colours
*Although it is very handy
to have earth colours on
your figure-painting
palette, they can be easily
simulated by mixing black
with orange, or orange-
yellow or orange-red. Keep
black away from any
colours mixed with white,
or you will probably create
the colour of mud.*

and knees are generally warmer than the hips, breast and stomach, which often contain cooler, pearly tints. For dark-skinned people, differences in local colour are less pronounced, but can still be detected.

However, remember that the local colour of all parts of the body will change according to the temperature and strength of the lighting. A figure that is illuminated by candlelight or tungsten light, which both contain a lot of light at the red end of the spectrum, appears warmer than one lit by, say, sunlight. You must forget whatever you thought you knew about flesh colour; instead, look intently at the colour you see in the given light. Close observation, as ever, is the key.

You also have to consider the areas of shadow on a figure. These areas are not directly lit, but almost always receive some light secondhand, so to speak, by reflection from the surroundings. A figure next to a blue wall, therefore, will have cool shadow tones.

As always in painting, it is important that you look closely at the relative warmth and coolness of the colour of each part of the subject. In figure painting, using cool colours for the shadows and warm for the lit areas, and vice versa, is a useful way of showing light fall and achieving solidity without large tonal contrasts. Modelling form with colour in this way is perhaps best exemplified in the work of Paul Cézanne (1839–1906).

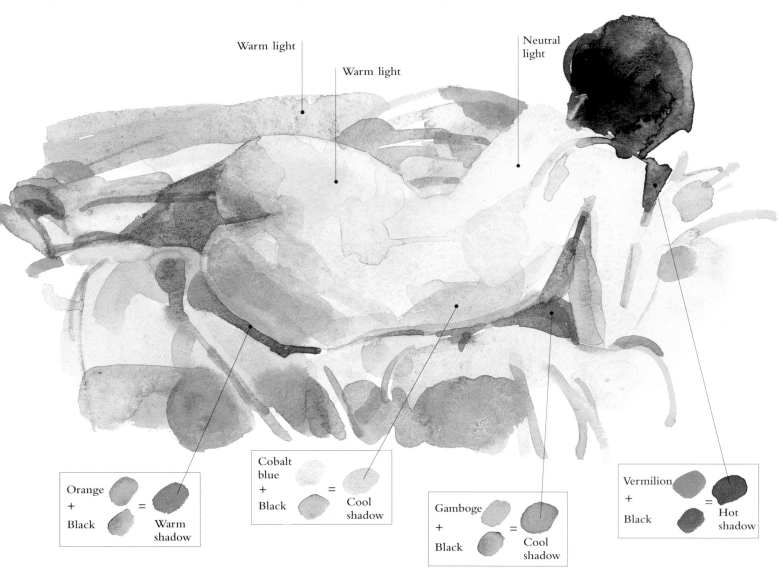

Warm light

Warm light

Neutral light

Orange + Black = Warm shadow

Cobalt blue + Black = Cool shadow

Gamboge + Black = Cool shadow

Vermilion + Black = Hot shadow

Using black

Beginners are often told that black, as a non-colour, must be avoided. However, as you can see, freshness and clarity are not sacrificed in any of the four black mixes labelled here. Note, though, that black features only in the shadow areas.

White, of course, is not used as a pigment in pure watercolour drawings, as the lightness of colour is controlled by the amount of paper colour, usually white, that is allowed to shine through the washes.

PRACTICE EXERCISE

THE AIM OF THIS EXERCISE is to emphasize the play of warm and cool colours in a figure, using Conté pencils on a pale-cream mount board. I chose a light-skinned model, as the warmer areas of local colour show pink. In dark-skinned models the warmer areas are masked by the skin pigmentation, resulting in less pronounced contrasts of warm and cool colour. However, you may find differences in colour temperature between the shadows and the lights in dark-skinned models, especially if there are contrasting colours in the background. Clothes can provide complementary colour, too – but do not cover your model too fully.

MATERIALS

Selection of Conté pencils

1 *Draw in delicate outlines to place the model. Then start to suggest some of the warm and cool passages with small areas of tone on the chest, the shoulder, hand and elbow of the right arm, and the forearm of the left arm.*

2 *Continue to build up the main warm and cool areas of the upper body. I used raw sienna, burnt sienna, a pale blue, a cool blue-green, a yellow-green and a cool pink. Also start to indicate the colours on the bed, taking heed of the interplay between them and the flesh tones.*

3 *As the top half takes shape, move down to the area of shadow on the upper thighs. This has a cool, pearly colour, so I crosshatched pale blue and yellow-green over the underlying raw sienna. I used raw sienna and burnt sienna to position the lower legs.*

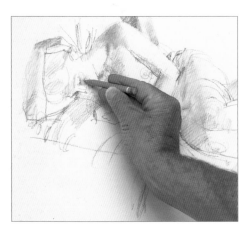

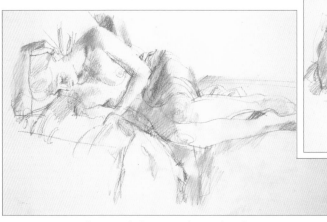

4 *Return to the upper body to play off the cool shadow on the shoulder against the warm tinge of the upper chest and cheeks. I used raw sienna, pale blue and a little mid-grey for the shadow, and pink and raw sienna for the warmer passages of colour.*

5 *Do not to be too definitive about the dressing gown at this stage – each time your model moves it is likely to be disturbed. Make some generalized indications of its form, but leave the final details until the end. Inset: I continued working up the warmer colours of the face and the right hand with pale-yellow pink – often somewhat erroneously called flesh pink.*

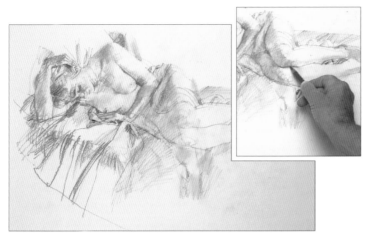

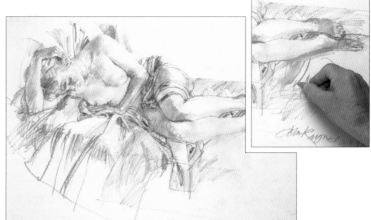

6 *I built up the left forearm with raw sienna and burnt sienna to create a strong, warm colour. Draw in some of the bed cover – describing its form rather than blocking in solid colour. Inset: I deepened the shadow in the cool area of the thighs by crosshatching yellow-green, raw sienna, grey and purple-blue, and then rubbing them together. For the much warmer knees, I used pink and burnt sienna.*

7 *I then drew in the final position of the model's dressing gown, using the purple-blue and pale-blue crayons with a hint of the cool pink rubbed in. Inset: For the feet, which are in shadow, I used the same colours as for the thighs. However, the model's right foot receives some reflected light from the bed cover; I therefore used orange over the underside of this foot, as well as to draw in the fabric folds.*

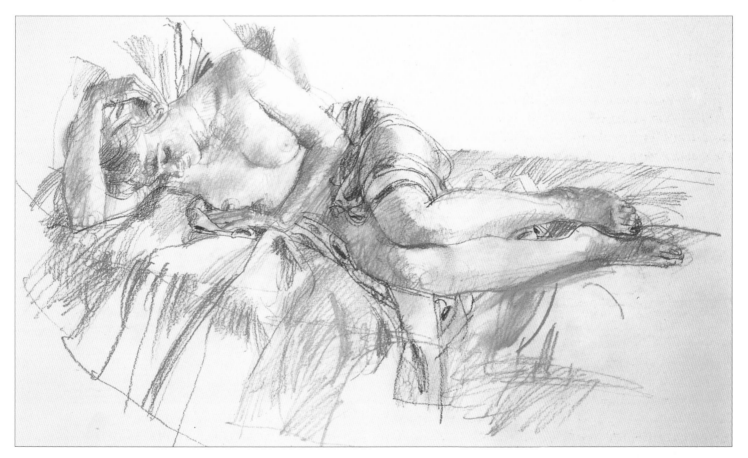

The finished drawing

Throughout this drawing I have accentuated the play of cool and warm colours. Look, for instance, at the two forearms. We can see the top side of her left forearm, and – since this is usually much warmer than the underside – I have used burnt and raw sienna. By contrast, the underside of her right forearm is showing, so I have used grey and pale blue here to qualify the warmth of the siennas.

MEASURING METHODS

*There are two very simple ways of evaluating the proportions
of your subject and transferring them to your paper – using a pencil
and thumb, and using a grid.*

HOLDING A PENCIL up to your model is the time-honoured method of measuring one part of your subject in order to compare it with another. To check the height of the head, for example, first line up the tip of the pencil with the top of the head, then slide your thumb down the pencil until it lines up with the bottom of the model's chin. By holding your thumb in place, you can move the pencil to any other part of the body to compare it to the height of the head. For this to work, the pencil must always be the same distance from your eye: to ensure this, always hold it with your arm fully extended. Also, the pencil needs to be constantly perpendicular to your arm.

Using a grid takes us one step further. The grid that I use is simply a rectangular viewing frame divided into equal squares by cotton thread (see *Making a grid*, opposite). Like the thumb and pencil method, this allows you to compare the proportions of various parts of the body. Furthermore, it enables you to comprehend the shape of the overall pose and to check the alignments of different parts of the body.

Use the grid only as a viewing guide – do not try to plot each piece of the figure that you can see in each square on a similar grid on your paper. This requires holding both the grid and your head absolutely still throughout the drawing – a virtually impossible task.

THUMB AND PENCIL MEASURING

THE PRINCIPLE OF THIS method of measuring is clearly seen in this diagram. Select a dimension on your model, such as the length of the head, and mark it with your thumb on the pencil. Move your straight arm to compare this with another dimension on the model, such as the length of the lower leg.

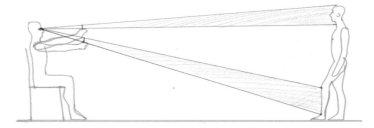

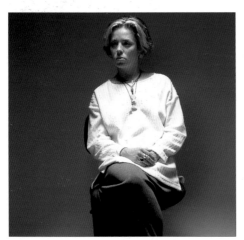

Selected pose
To compare the measurements of various parts of the body in this pose, I used the pencil and thumb method. (For photographic reasons, the figure is out of focus in the succeeding frames, but in real life you would see both pencil and pose clearly.)

First measure
Hold the pencil with your arm outstretched against the model. Select any part of the body to measure – here, I've chosen the width across the model's shoulders. Simply align the end of the pencil with one shoulder and align your thumb with the other one.

Second measure
Keep your thumb in the same place, then compare it to other dimensions of the body. Here, you can see that the distance across the shoulders matches the distance from the chin to the hands. Now make sure that these two distances are the same in your drawing!

Making a grid

You can make a grid for framing and measuring your view of the subject either by drawing it on a piece of clear plastic or, as described below, by stretching threads across a rectangular aperture.

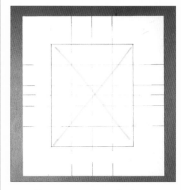 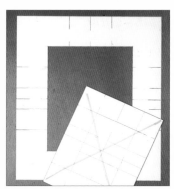 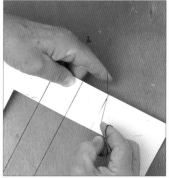

1 On mount board, draw a rectangle 8 x 9 ³/4 in (200 x 250 mm) and divide each side into 2 in (50 mm) units. Extend these divisions to the edge of the board.

2 Using a craft knife against a metal straightedge, cut out and discard the 8 x 9 ³/4 in (200 x 250 mm) rectangle to create a viewing frame.

3 Nick the edges of the board at each 2 in (50 mm) division. These cuts are to locate the threads of the grid, so only make them about ¹/8 in (3 mm) long.

4 Loop a continuous length of strong thread across the aperture from one slot to the next. This will form a regular grid of 2 in (50 mm) squares.

USING A GRID

HOLDING UP A GRID AGAINST your model allows you to check not only the proportions of various body parts (see below), but also their alignment. By looking at the centre vertical of the grid, for example, you can see that the model's right knee is aligned with the left side of her face. By moving the grid to different positions, either laterally or up and down, many other alignments become apparent. Even viewing the subject through a square or rectangular frame with no subdivisions at all is surprisingly useful in assessing the overall shape of the pose – helping you, for instance, to make a decision as fundamental as whether to use a landscape (horizontal), portrait (upright) or square format.

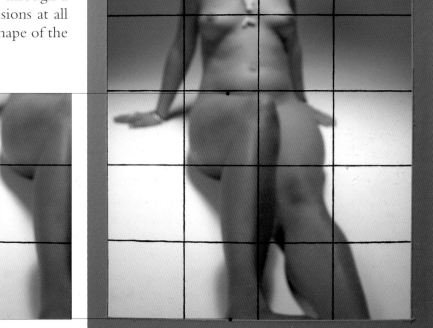

Comparing proportions

In certain poses, the relative proportions of the various body parts can be rather unexpected. In the three squares here, for instance, you can see that the length of the thigh is little more than one square, while the length of the lower leg – from knee to ankle – is equal to three squares in length. Referring to the main grid, see how the torso is almost contained by two squares, while the legs – even without the feet – occupy the best part of six squares.

PERSPECTIVE

*Perspective may seem a little intimidating, but some knowledge of its
basic principles can help you understand and even foresee the apparent
distortions of a variety of poses from a variety of viewpoints.*

LINEAR PERSPECTIVE IS, quite simply, a system that enables you to create the illusion of three-dimensional space on a flat surface. When it is done successfully, the relative positions and sizes of objects in the picture appear just as they do to the eye in real life. For instance, objects further away from you appear smaller than those close to you, while objects that recede from your view appear to be compressed in length – an illusion known as foreshortening.

If your observation was acute enough for you to draw exactly what you saw, then a knowledge of perspective would add nothing – but most of us need a little help to see accurately. There are a few basic concepts that will help you to understand how the perception of objects changes as you change your viewpoint. The full procedures for measuring and projection, however, are quite demanding. Anyone who wishes to pursue the subject should consult specialist books.

ONE-POINT PERSPECTIVE

The first principle of perspective is that all parallel straight lines will, when seen from anywhere other than straight across your vision, appear to converge on the horizon at a vanishing point. This method demonstrates how to draw a series of shapes in perspective. You can then use the repeated shapes to help you draw a foreshortened figure. To make things easier, draw the first square or rectangle of this exercise by judgement.

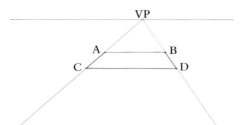

1 *Draw a horizon line and then two straight lines converging on a vanishing point (VP). Draw two more lines parallel to the horizon to make a square in perspective (ABCD).*

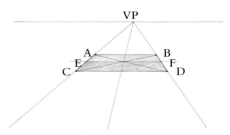

2 *Draw in diagonals AD and CB. The intersection point marks the centre of the ABCD square. Through this intersection, draw a horizontal line (EF) and a line to the vanishing point.*

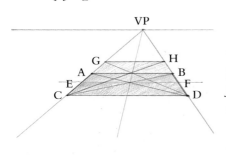

3 *The two halves of the square, shaded orange and red, are the right shape and size in perspective for this viewpoint. Now project a line from C through the intersection point of line AB and the central orange line to the green side line (H). Repeat from point D. Draw a line through H, parallel to AB. The new blue square (GHAB) is a repeat in perspective of the square ABCD.*

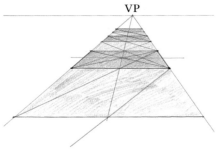

4 *Using the Step 3 instructions, similar squares can be projected* ad infinitum, *becoming progressively smaller. As you can see from the large square in the foreground, the method also works forward.*

5 *By narrowing the angle of the original perspective side lines, you will attain a higher eye level. You can also extend the rows of rectangles outward.*

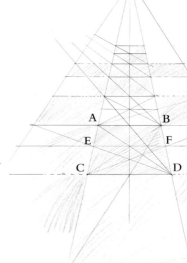

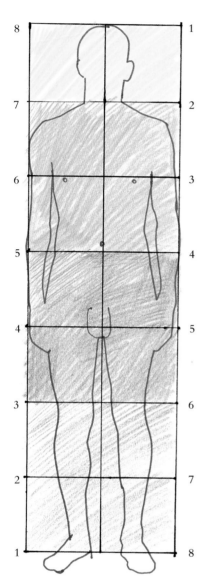

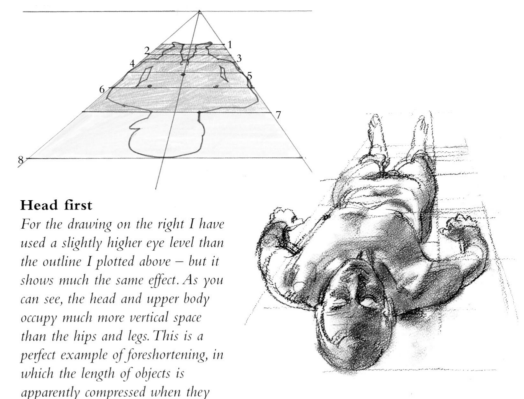

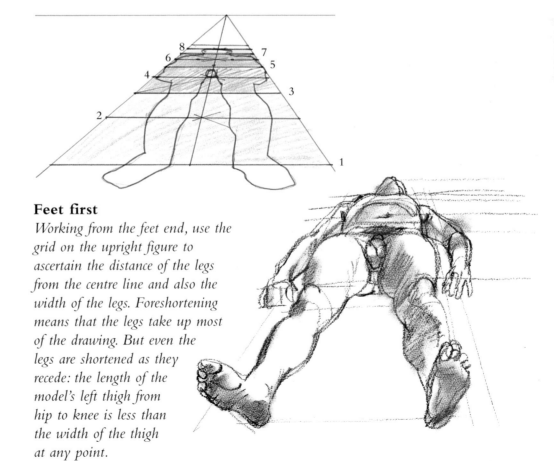

Head first

For the drawing on the right I have used a slightly higher eye level than the outline I plotted above – but it shows much the same effect. As you can see, the head and upper body occupy much more vertical space than the hips and legs. This is a perfect example of foreshortening, in which the length of objects is apparently compressed when they recede from your view.

Gridding up

How does showing a series of squares in perspective relate to figure drawing? Take one of the squared-up figures on page 59, and number the squares 8–1 on one side and 1–8 on the other. Number the corresponding areas on your perspective grid and plot the figure outline onto it. Place the nipples and the umbilicus first, as they nearly coincide with grid lines 6 to 3 and 5 to 4 respectively. Once completed, you will have an outline of the figure in perspective, which you can use as a guide for drawing.

Feet first

Working from the feet end, use the grid on the upright figure to ascertain the distance of the legs from the centre line and also the width of the legs. Foreshortening means that the legs take up most of the drawing. But even the legs are shortened as they recede: the length of the model's left thigh from hip to knee is less than the width of the thigh at any point.

TWO-POINT PERSPECTIVE

IF YOU MOVE YOUR viewpoint away from a straight-on view of a square or a cube, or any object that could be contained by them, another vanishing point comes into play. For a cube, the two visible side planes vanish to a different point, hence the term two-point perspective.

As you can see in the diagram (right), both vanishing points are on the same horizon, which corresponds to the viewer's eye level. But this time neither vanishing point coincides with the viewer's centre of vision.

The exercise below uses the same methods shown on the previous pages to project a series of cubes to two vanishing points. This creates a three-dimensional square in perspective that you can then use to frame and contain a prone figure. In this case, I have used it to draw a child's doll (see opposite page). Once you have completed this exercise, the principle will remain in your head so you will not have to draw the surrounding frame every time you draw a fully reclined figure.

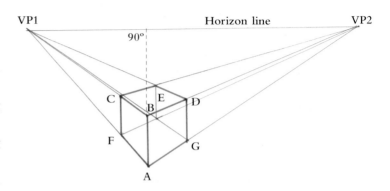

To construct a cube in perspective, first draw a line at 90° from the horizon. From the point (A) draw lines at different angles to meet the horizon, vanishing at VP1 and VP2. Judge the height of the fore edge of the square (B) and draw lines to VP1 and VP2. Draw two verticals (CF and DG) where you judge the sides of the cube to be. Draw a line from C and F to VP2, and from D and G to VP1. Where the lines intersect (E) creates the back edge.

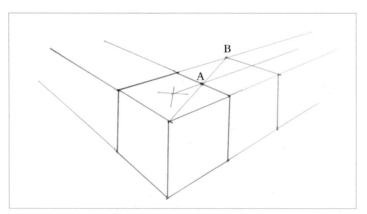

1 *Using the cube, draw two diagonals from the corners of the top plane to find its centre (green X). Draw a line from the X towards VP2 to find the centre of the top right edge (A). Draw a line from the near corner through A to the vanishing line projected from the cube's top left edge (B).*

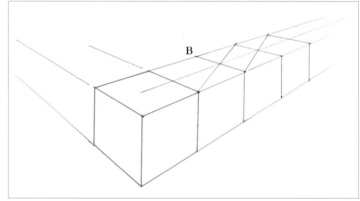

2 *From B you can construct a repeat cube in perspective. And by using the same principles in Step 1, you can project cubes ad infinitum towards the VP. (Note that the sides are assumed to be vertical — in fact, from the raised viewpoint, they would converge slightly downwards.)*

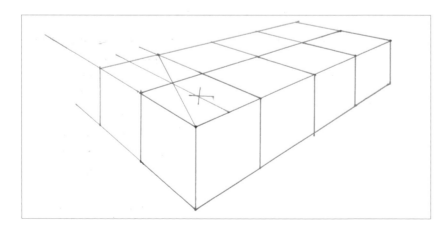

3 *Projection towards the other vanishing point, using exactly the same principles, produces another cube which is the first of another row of cubes. Once you have drawn eight cubes in two rows of four, you will have a form similar to a long, low building. This can be used to contain a prone figure.*

PRACTICE EXERCISE

THIS EXERCISE USES the long, low building form to draw a doll lying down. The rules of perspective that apply to a building apply equally to her. The lines running across her body converge towards the left vanishing point, while the lines running along her body vanish to the right. Thus the doll will recede in two directions, though most noticeably to the right.

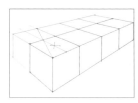 To draw a prone figure, use a perspective grid based on a long, low building form.

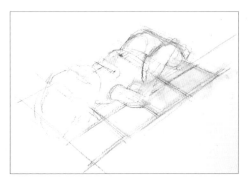

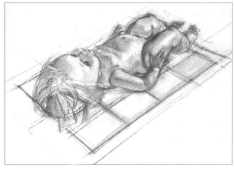

1 *Using charcoal, I drew a rough grid representing the ground plan of the 'building' I created on the opposite page. Then I began to draw the doll, keeping the long, low building form in mind (see opposite page).*

2 *I continued to draw the doll, always referring to the building form. Use the three-dimensional box to check that the eyes, nipples and knees are aligned correctly. (If you draw a line through the two eyes, it should meet at the vanishing point you used to construct your building form.)*

MATERIALS

Charcoal

Kneaded eraser

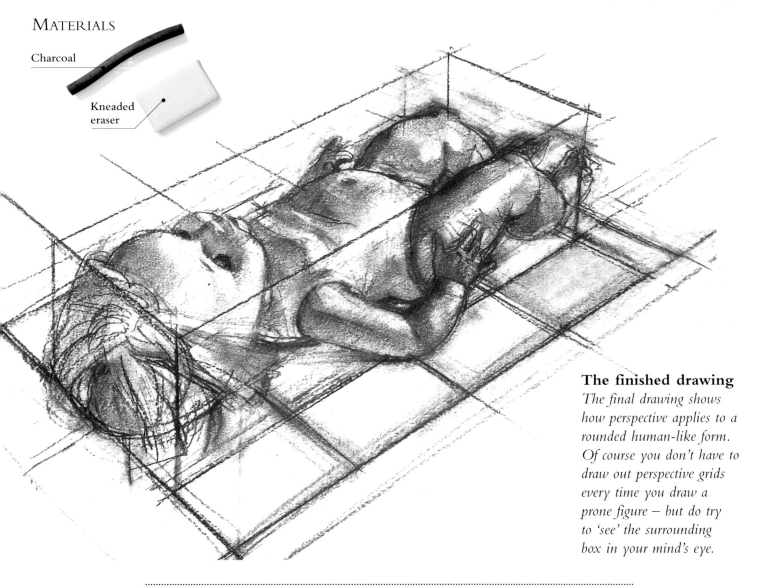

The finished drawing
The final drawing shows how perspective applies to a rounded human-like form. Of course you don't have to draw out perspective grids every time you draw a prone figure – but do try to 'see' the surrounding box in your mind's eye.

PRACTICE EXERCISE

JUST AS THE PRONE figure can be seen in terms of a long, low building, so the sitting or kneeling figure relates to a low building supporting a high-rise block. The high-rise section in the diagram on the right (drawn in orange) shows that once the building/figure rises above the horizon, the vanishing lines slope downwards. This indicates that you are now looking up at the top section of the figure. For the doll itself, though, we will be looking down.

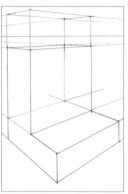

For a sitting figure, use a three-dimensional 'L' perspective grid.

1 *In the case of this doll, you can see that lines through the shoulders, elbows, hips and knees are parallel. In life, figures rarely adopt such a neat pose. By visualizing a regular surrounding framework, though, you can judge the extent to which the pose has deviated from the symmetrical.*

MATERIALS

2B pencil

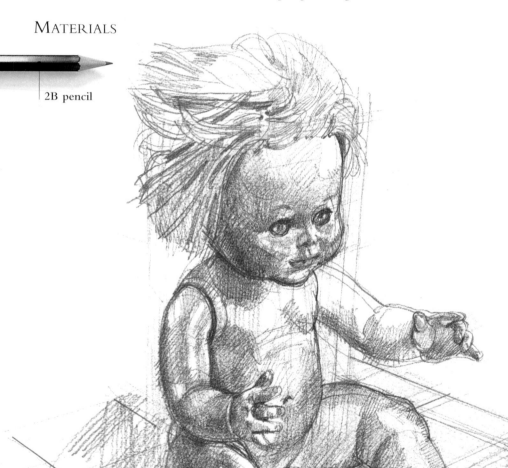

2 *I initially left out the arms as they were at slightly different angles and therefore deviating from the perspective grid. Now I drew them in with the different levels in mind.*

The finished drawing
It does no harm to draw the enclosing 'building' in lightly. You can use it to check that everything sits in perfect perspective. In the final drawing, the 'building' will be overpowered by the strengthened modelling, and viewers will see through it to the subject.

THREE-POINT PERSPECTIVE

FOR NORMAL EYE LEVELS, two-point perspective gives an adequate explanation of what is going on – but from a very high or very low viewpoint a third direction of recession is observed. Imagine that you are looking down at a tall building from an even higher one, as in the top row of drawings below. The verticals appear to converge downwards and the imaginary spot at which they meet is a third vanishing point.

A similar thing happens when you look up at a tall structure. Now the third vanishing point is up in the sky. When drawing a model standing on the floor, you have to be very close in and sitting at a low level to see this effect. However if the model stands on, for example, a table, then, although you may lose sight of the feet, you would have a similar view to the bottom row of structure diagrams below.

From a high viewpoint

From a viewpoint that enables you to look down on your subject, vertical lines appear to converge downwards to a third vanishing point somewhere below the ground.

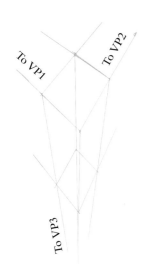

1 *Looking down on your subject, the top and sides vanish towards the left and right (VPs 1 and 2) as normal and the verticals vanish downwards to VP3.*

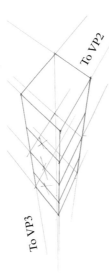

2 *I have divided the 'building' into four cubes, using the methods described for one- and two-point perspective. Again, each cube is in reality the same size, but they are shown receding in perspective.*

3 *If you imagine that this tower encloses a human figure, the red area would contain the upper half of the body, while the legs must be accommodated in only the small blue area.*

From a low viewpoint

From a viewpoint that enables you to look up at your subject, vertical lines will appear to converge to a third vanishing point located somewhere in the sky.

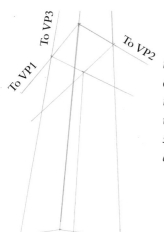

1 *Here we have a similar tower shape to the one above, except that from the low viewpoint the sides now converge upwards.*

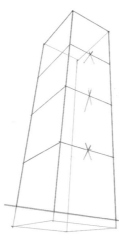

2 *Now I have divided the tower into cubes as before, but to have it supported rather than floating, I have added the edge of the platform it must be standing on to afford me this low view.*

3 *With the two upper cubes coloured blue and the lower ones red, you can see that now it is the top half of the figure that must be squashed into the small blue section.*

PRACTICE EXERCISE

IN THIS EXERCISE, with the model viewed from above, there are three vanishing points – one to her left, one to her right and one below her. It is the third, downwards direction of recession that is most prominent, and most difficult to draw! As the model is upright and I am using a close viewpoint, the foreshortening in this direction is extreme. When confronted by such foreshortening, it is hard to believe your own eyes. You often draw what you are familiar with, rather than what is there. To counter this, take note of unlikely correlations and shapes, and make a few construction marks to remind you of the perspective boxes (see *Foreshortening*, right).

Foreshortening

With extreme foreshortening, you need as many aids as possible to enable you to see the figure correctly. Use perspective boxes and construction lines to come to terms with the apparent distortions.

As the model had pivoted slightly at the hips, I drew two perspective boxes set at slight angles to each other (left). I also noted the distortions created by the foreshortening (right). The bottom pink line reveals that the elbow is lower than the left foot, while the red lines with arrows show that the right arm is approximately three times as long as the depth of the thigh.

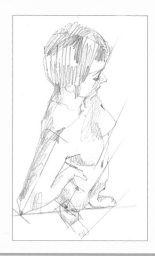

MATERIALS

Selection of Conté crayons

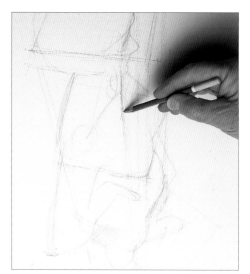

1 *For this exercise, you do not need to be a great deal higher than your model, as long as you are close enough. Make sure you can see the top of the feet as well as something of the legs, torso and face. Then begin by lightly plotting the two perspective boxes.*

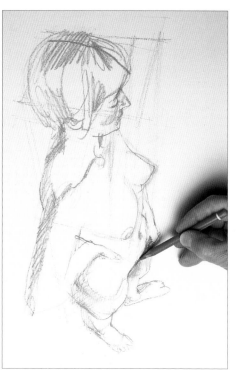

2 *Bearing in mind the distortions of the body shown in the drawing above right, draw in the basic shapes of the figure in red – this is more dominant than the blue of the construction lines.*

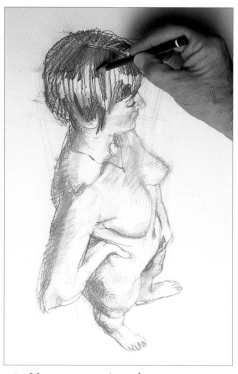

3 *You can now introduce stronger colour and form into the helmet of hair covering the head. Be careful to render the facial features correctly – foreshortening brings them all very close together.*

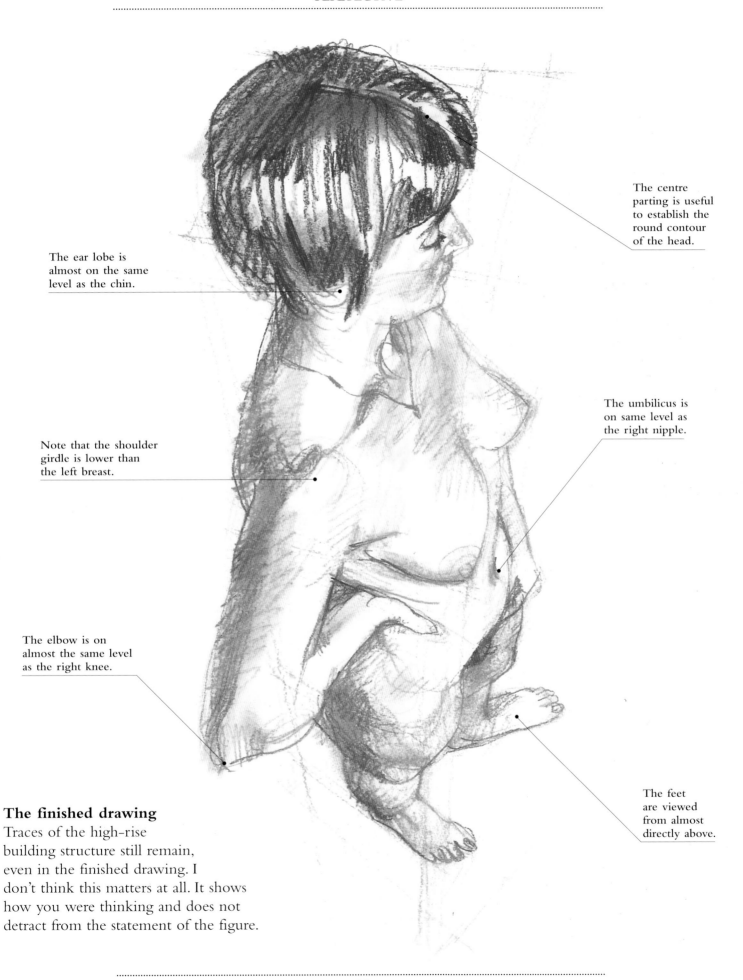

The centre parting is useful to establish the round contour of the head.

The ear lobe is almost on the same level as the chin.

The umbilicus is on same level as the right nipple.

Note that the shoulder girdle is lower than the left breast.

The elbow is on almost the same level as the right knee.

The feet are viewed from almost directly above.

The finished drawing

Traces of the high-rise building structure still remain, even in the finished drawing. I don't think this matters at all. It shows how you were thinking and does not detract from the statement of the figure.

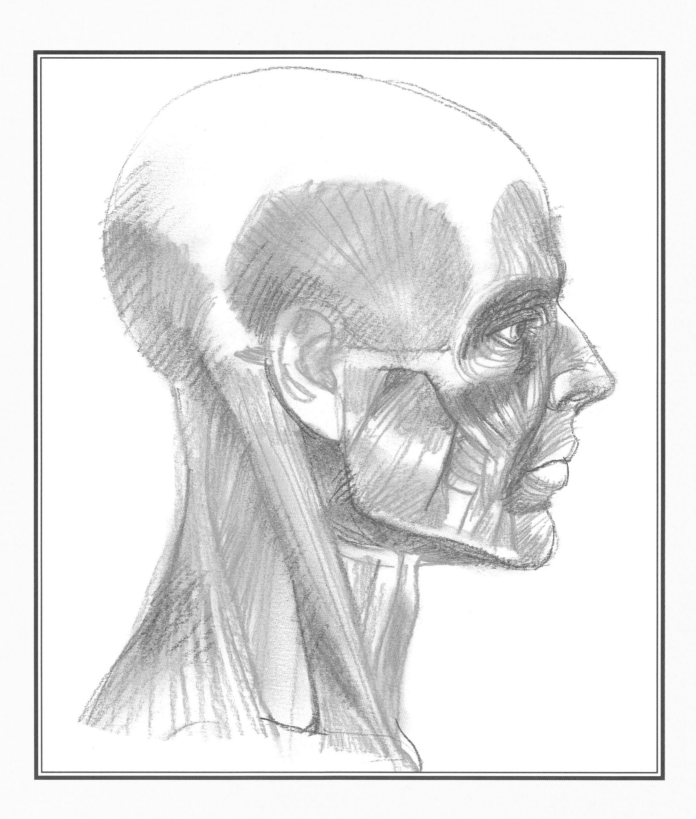

ANATOMY

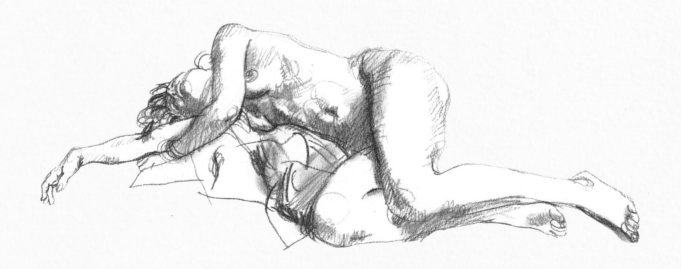

PROPORTIONS

Attempts to classify the body's proportions are always defeated by the infinite variety of the human race. Some knowledge of the 'norms', however, can help you to evaluate the proportions of any given model.

SINCE ANCIENT GREECE, people have tried to define the proportions of the human form, searching for a system that displays some mystical or Godly purpose or, at the very least, a mathematical coherence.

However, it seems that for every rule made in regard to proportions, there is a case that breaks it. Indeed, if the goal for some has been to arrive at the 'perfect' human form, for figure artists it is the variations and peculiarities of the body that are the source of never-ending fascination.

Nevertheless, you should be familiar with 'standard' proportions, if only to show how much your model departs from them. The most notable classification is the number of times the length of the head fits into the total height of the body. The 'norm' is about seven (or 1:7), and this is the ratio shown in the adult figures opposite. However, it is not unusual to find ratios of 1:6.5 or 1:7.5. Some people even have a rather heroic 1:8 ratio – the figure that the Greek sculptor, Praxiteles, saw as the ideal proportion.

Also note the line dividing the body into two halves, shown in red below. As you can see, it is often just above the pubis, regardless of height, sex and build. In other words, nearly half the adult height is in the legs.

Children to young adults

It is important to note how large a baby's head is in relation to its body – a baby's total height is only about four times the height of its head, compared with a figure of around seven for an adult. The limbs show the most dramatic growth in the early years: by the age of three they usually make up about half the height.

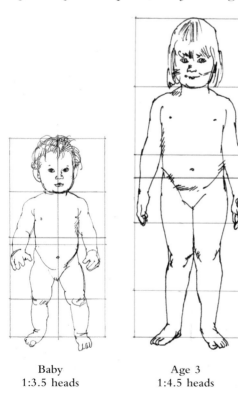
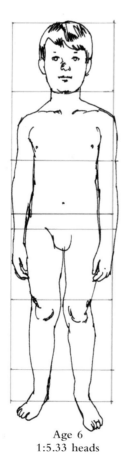
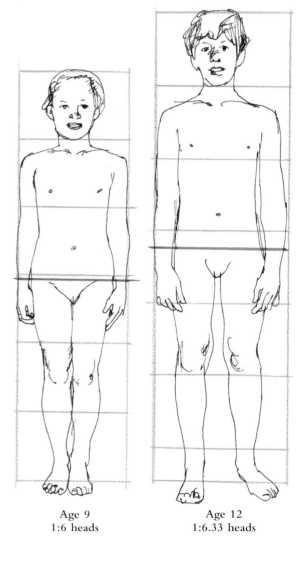

Baby	Age 3	Age 6	Age 9	Age 12
1:3.5 heads	1:4.5 heads	1:5.33 heads	1:6 heads	1:6.33 heads

Key

The orange grid divides the overall height of each body, from the heel to the top of the head, including normal hair covering, into units of head size. The red line is at the halfway point of each individual's height.

Between sexes

These two drawings represent the male and female archetypes. The fundamental difference in shape is that the female has a wider pelvis, with fat depositions smoothing out the contours. The male has narrower hips and also shows heavier upper body build. It must be stressed these are generalizations – there are huge individual variations to this 'norm'.

Different builds

Here you can see how variations in individual build can present very different silhouettes. The man on the left has well-defined musculature with little or no fat, while the more slender build of the man on the right is augmented and softened by an overall layer of subcutaneous fat.

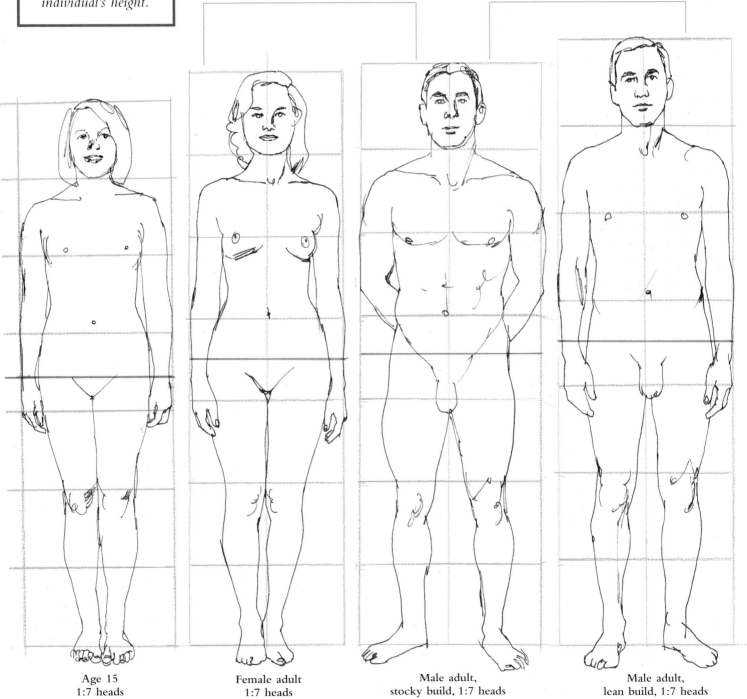

Age 15
1:7 heads

Female adult
1:7 heads

Male adult,
stocky build, 1:7 heads

Male adult,
lean build, 1:7 heads

THE SKELETON

It is not necessary for the figure artist to know the Latin name for every bone in the body, but some comprehension of the body's underlying skeletal structure is invaluable in rendering its outward appearance.

SINCE THE RENAISSANCE, the great figure artists have supplemented their artistic skills with anatomical learning. Michelangelo, Leonardo and Raphael dissected and analyzed corpses, while Rembrandt famously studied with the Amsterdam Association of Surgeons.

Any study of the skeleton has to start with the spine. It can make considerable bending and twisting movements, taking the attached rib cage (thorax) with it and thereby radically changing its relationship with the pelvis. Recognition of these movements is vital to understanding the pose of the body. It is by the twists and turns of the backbone that the body performs the tricky task of balancing upright and also responds to the different demands of relaxation.

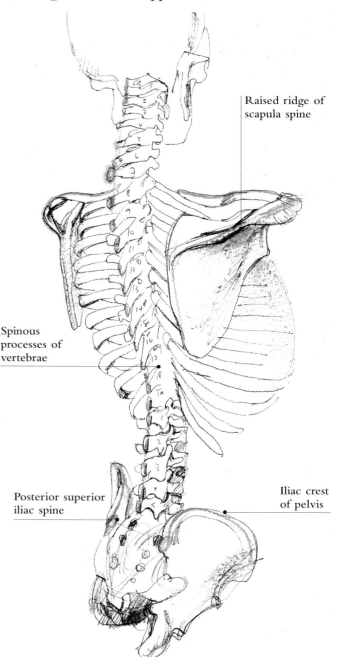

Raised ridge of
scapula spine

Spinous
processes of
vertebrae

Posterior superior
iliac spine

Iliac crest
of pelvis

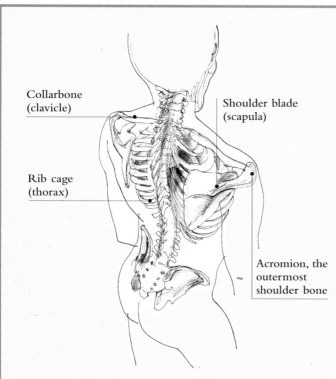

Collarbone
(clavicle)

Shoulder blade
(scapula)

Rib cage
(thorax)

Acromion, the
outermost
shoulder bone

High view of the trunk skeleton

In this slightly higher view of the skeleton of the trunk, look at the prominence of the shoulder girdle, comprised of the shoulder blade, the acromion and the collarbone. Note also how the top of the rib cage, or the thorax, is much narrower than the lower part.

The bones visible in the torso

Here the bones that lie just below the skin – and are therefore identifiable in the live model – are indicated in orange. They provide useful signposts to the overall position of the body. The most obvious are the spinous processes, spurs of bone attached to each vertebra. Together they form a depression or, in thin people, a knobbly ridge.

The upright bending spine

Always try to appraise your model anatomically before you begin drawing. Note that the weight here is supported mainly by the right leg. To achieve balance, the upper body has shifted over this leg and, to maintain this weight shift in a relaxed way, the pelvis tilts down to the left and the shoulder girdle tilts down to the right.

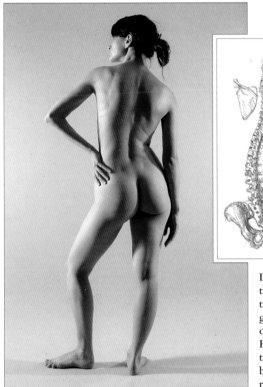

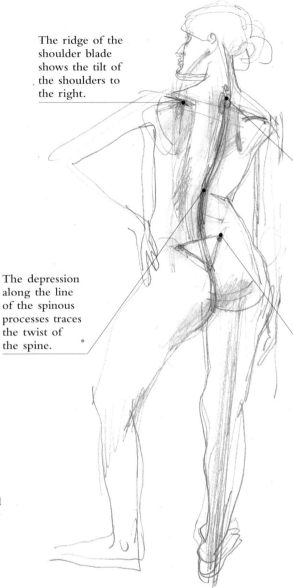

The ridge of the shoulder blade shows the tilt of the shoulders to the right.

The seventh cervical vertebra appears as a noticeable lump and indicates where the neck begins.

The depression along the line of the spinous processes traces the twist of the spine.

The two depressions of the posterior superior iliac spines indicate the pelvic tilt down to the left.

Look closely at the position of the spine for a guide to the overall pose. Here, it is twisted to shift the upper body over the right foot.

The spine in repose

This classic pose shows the spine in a relaxed position. The weight of the model is supported by the pelvis and the upper arm so the spine sags like a washing line. (The extent of the curvature will depend on the flexibility of your model.) The angle of the pelvis can be judged by looking at the triangle formed by the top of the buttock division and the two depressions created by the posterior superior iliac spines.

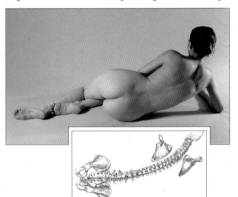

The relaxed spine gently curves under the pull of gravity.

The posterior superior iliac spines help determine the angle of the pelvis.

The trunk sags, shown by the curve of the spine.

The left hip projects upwards as the pelvis is a rigid structure.

The right shoulder is pushed up by the propped right arm.

THE SKELETON – FRONT VIEW

READING THE TILT OR TWIST in the trunk is slightly more difficult when you view the body from the front. There is no prominent central line, equivalent to the spine at the back. However, by looking closely at the tilt of the shoulders and the pelvis, you can see exactly how the torso is positioned. The collarbones are usually visible and indicate the angle of the shoulders, while the iliac crests are prominent at the edge of the hips and indicate the angle of the pelvis. You can see in the diagram on the right how the model's torso is leaning to her left in response to the slight pelvic tilt down to her right.

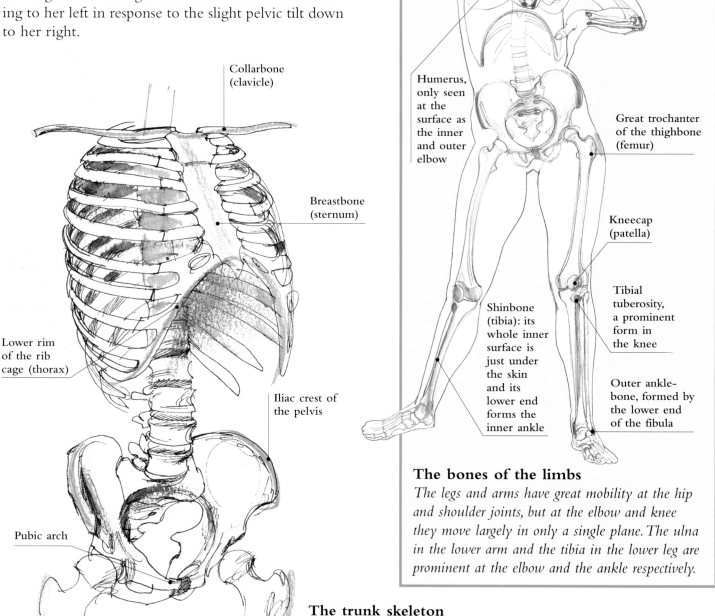

Collarbone
(clavicle)

Breastbone
(sternum)

Lower rim
of the rib
cage (thorax)

Iliac crest of
the pelvis

Pubic arch

Ulna, close
to the surface
throughout
its length

Humerus,
only seen
at the
surface as
the inner
and outer
elbow

Great trochanter
of the thighbone
(femur)

Kneecap
(patella)

Tibial
tuberosity,
a prominent
form in
the knee

Shinbone
(tibia): its
whole inner
surface is
just under
the skin
and its
lower end
forms the
inner ankle

Outer ankle-
bone, formed by
the lower end
of the fibula

The bones of the limbs

The legs and arms have great mobility at the hip and shoulder joints, but at the elbow and knee they move largely in only a single plane. The ulna in the lower arm and the tibia in the lower leg are prominent at the elbow and the ankle respectively.

The trunk skeleton

Again, the orange markings show where bones are detectable through the skin. The collarbones articulate with the breastbone, which allows them to follow the movements of the shoulders. The lower rim of the rib cage is prominent only when the lungs are filled. The iliac crests of the pelvis are usually seen as depressions.

THE SKELETON — SIDE VIEW

OBVIOUSLY THE DIRECTION of a limb can be clearly seen and interpreted when it is across your vision. The difficulty comes in the side view, when it is inclining away or towards your line of sight. Again, the places where the bones come close to the surface afford useful reference points (see *The bones of the limbs*, left). Note, in particular, the outer protuberance at the top of the thighbone (femur), known as the great trochanter, and the bump marking the top of the shinbone (tibia), known as the tibial tuberosity.

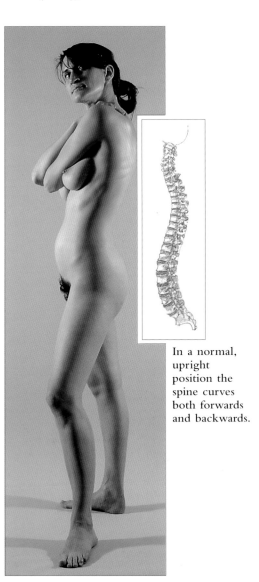

In a normal, upright position the spine curves both forwards and backwards.

The upright back in profile
The natural bends of the upright, balanced spine are readily apparent from the side view. When drawing, pay close attention to the extent of this curvature. Also try to pick up clues to any lateral bending. If one leg is straight and weight-taking, as here, the other tends to be bent and relaxed, indicating pelvic tilt.

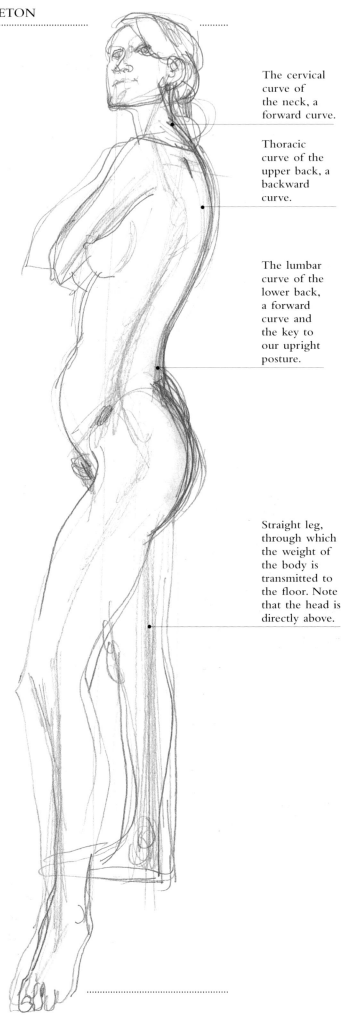

The cervical curve of the neck, a forward curve.

Thoracic curve of the upper back, a backward curve.

The lumbar curve of the lower back, a forward curve and the key to our upright posture.

Straight leg, through which the weight of the body is transmitted to the floor. Note that the head is directly above.

THE MUSCLES

The skeleton provides the internal structure of the figure, but the muscles are chiefly responsible for the external, visible shape. Try to identify the major muscles and how their form changes in different poses.

TO GAIN A COMPLETE understanding of human musculature, it is best to draw from young, fit models. Their muscles are particularly well-defined as there is little but skin overlaying them.

But don't worry if your model does not conform to an athletic ideal. Most of us have some fat overlaying our muscles. Women tend to acquire fat on the hips, bottom and thighs at puberty, while both men and women may carry bulky weight around the abdomen and upper body. In all but the obese, though, it is still possible to see the main emergent points of the skeleton and from them the principal muscle attachments.

Muscles are divided into two types – extensors and flexors. The extensors straighten or extend while the flexors bend or flex. I have coloured extensor groups in red and flexors in blue.

The front of the trunk is dominated by flexors, as they all contribute to bending the body or pulling the

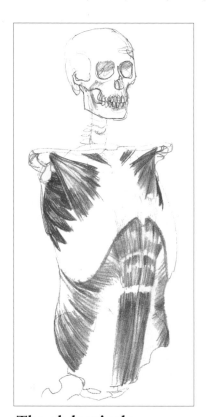

The pectorals and deltoids
Prominent at the front of the body, especially in a well-muscled male, are the pectorals. They dive under the deltoid to join the upper arm bones. The near deltoid here is coloured both red and blue as it wraps around the whole shoulder joint, and thus sometimes assists the extensors and sometimes the flexors.

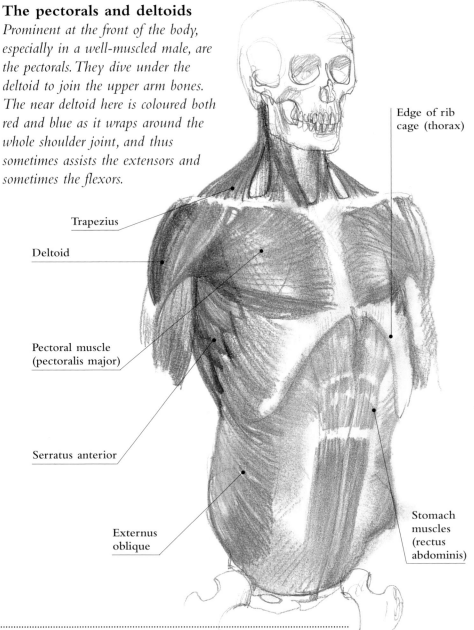

Trapezius

Deltoid

Pectoral muscle
(pectoralis major)

Serratus anterior

Externus
oblique

Edge of rib
cage (thorax)

Stomach
muscles
(rectus
abdominis)

The abdominals
The abdominals are only pronounced in what is commonly called a 'washboard' stomach. They consist of two bands of muscle that join the pubis to the rib cage. The rib-like muscles beneath the armpits, drawn in red, are the only visible surface signs of a large and deep muscle of the back, the serratus anterior.

shoulders forward or tucking the chin in. The muscles of the upper trunk largely follow the form of the rib cage, while the form of the abdominal muscles is largely dictated by their role as a 'sack' holding in the entrails.

The musculature of the back is probably the most poorly understood area of human anatomy. Anatomical diagrams – which usually show only the outlines of the thin sheets of surface muscle – bear little resemblance to the forms that can actually be seen on the back of a live model. To understand these forms, you need to know about the deeper structure. Below, I have drawn the three layers of back muscles of the trunk successively over each other so that you can see the effect of the underlying layers on the surface ones. You could do the same as an exercise, by erasing as necessary or just by drawing more strongly.

The deepest back muscles

The deepest muscles of the back are known as the erector spinae group. These muscles are numerous and have complicated attachments, but basically they form two thick ropes of muscle which work like rigging to hold the spinal column erect. They define the form of the back, even though flatter muscles overlay them.

The middle layer of muscles

These muscles consist mostly of fairly thin sheets which have little effect on the surface form. The muscles over the scapulae, however, can be plump enough to leave the scapula spines visible on the surface as grooves. (In well-muscled models, near-to-the-surface bones usually appear as indentations.)

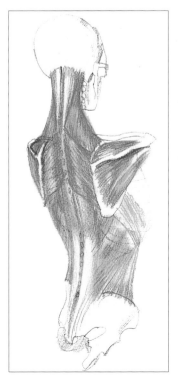

The surface muscles

These prominent muscles create the characteristic V-shape of the back. The white areas here represent tendons, parts of the muscles which do not contract. Although they are exceedingly strong, tendons have little bulk, consisting of either thin sheets or cords. A flat diamond shape is formed by the tendon attachments at the base of the neck.

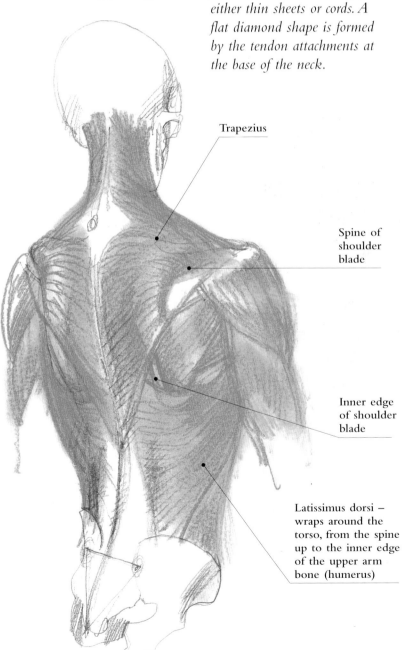

Trapezius

Spine of shoulder blade

Inner edge of shoulder blade

Latissimus dorsi – wraps around the torso, from the spine up to the inner edge of the upper arm bone (humerus)

THE MUSCLES OF THE LIMBS

LIMB MUSCLES WORK RATHER like cables. They are attached to the bones a short distance from the pivot point of each joint so that when they receive an impulse to shorten, they exert a pull which either bends the limb or straightens it.

As in the trunk, those muscles that bend the limb are called flexors (coloured blue), while those that pull and hold the limb straight are extensors (coloured red). These opposing groups act together, balancing each other. For example, when the biceps of the arm are flexing to lift a weight, the triceps are also working, although less vigorously, to give smoothness and control to the primary movement. So when a limb is actively lifting or supporting weight, all its musculature will appear tense and more defined than when it is at rest. Try to identify the major muscles and understand how their form changes in different positions.

It is a slight simplification to say that limb muscles only bend and straighten, as they are also involved in rotating the limbs. However, while these movements are clear to see, the muscular effort to activate them is rather too subtle to influence the form significantly.

Remember that the surface form is not entirely dependent on the musculature; most figures have some depositions of fat, and many have a great deal! Luckily, even on quite obese bodies it is usually possible to identify the near-the-surface bones by depressions and dimples (see *The Skeleton*, pages 60–63).

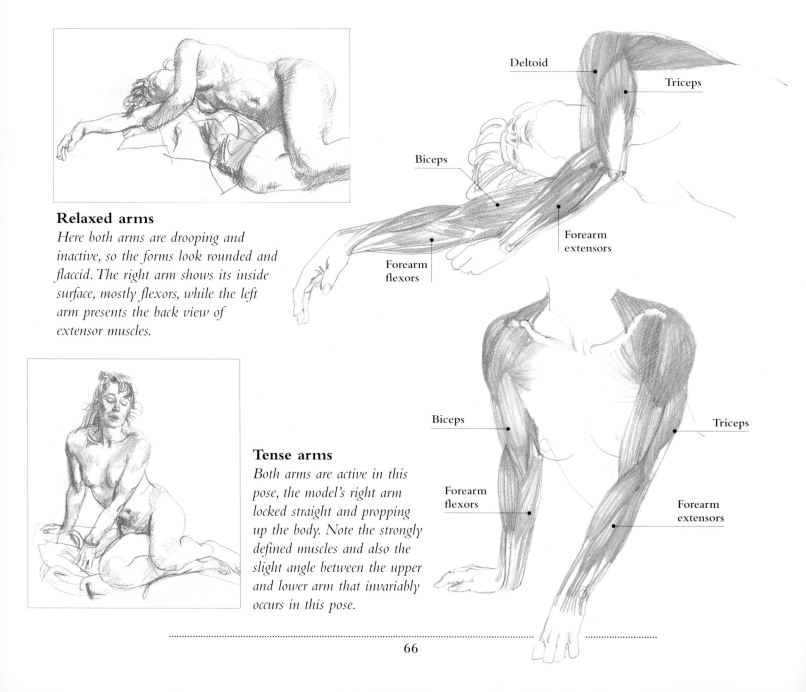

Relaxed arms
Here both arms are drooping and inactive, so the forms look rounded and flaccid. The right arm shows its inside surface, mostly flexors, while the left arm presents the back view of extensor muscles.

Deltoid

Triceps

Biceps

Forearm extensors

Forearm flexors

Tense arms
Both arms are active in this pose, the model's right arm locked straight and propping up the body. Note the strongly defined muscles and also the slight angle between the upper and lower arm that invariably occurs in this pose.

Biceps

Triceps

Forearm flexors

Forearm extensors

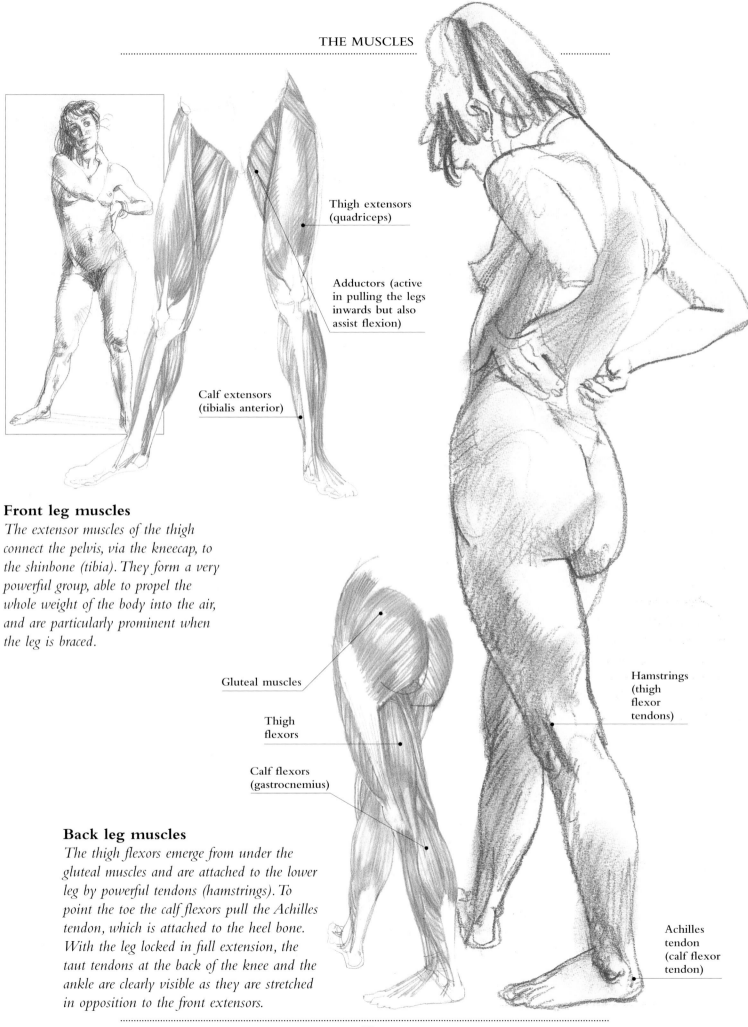

Thigh extensors
(quadriceps)

Adductors (active
in pulling the legs
inwards but also
assist flexion)

Calf extensors
(tibialis anterior)

Front leg muscles

*The extensor muscles of the thigh
connect the pelvis, via the kneecap, to
the shinbone (tibia). They form a very
powerful group, able to propel the
whole weight of the body into the air,
and are particularly prominent when
the leg is braced.*

Gluteal muscles

Thigh
flexors

Calf flexors
(gastrocnemius)

Hamstrings
(thigh
flexor
tendons)

Achilles
tendon
(calf flexor
tendon)

Back leg muscles

*The thigh flexors emerge from under the
gluteal muscles and are attached to the lower
leg by powerful tendons (hamstrings). To
point the toe the calf flexors pull the Achilles
tendon, which is attached to the heel bone.
With the leg locked in full extension, the
taut tendons at the back of the knee and the
ankle are clearly visible as they are stretched
in opposition to the front extensors.*

THE HEAD

As bone structure is largely responsible for the outward appearance of the head and face, the study of the skull is – for the figure artist – more important than any other part of the skeleton.

WHAT MAKES A particular face unique? The answer lies in large part in the structure of the skull. Unlike most of the other bones of the body, the skull is not covered by large amounts of muscle and tissue. As a result, the form of the head and face closely follows the form of the skull. So strong is this link that experts in anatomical sculpture can take a skull of unknown provenance and quite accurately re-create the original features of the person.

The skull comprises 22 bones, 8 of which make up the egg-shaped cranium that encloses the brain (see the drawings below). The other 14 bones form the face and the jaw. These 22 bones are common to humans of all races – but their size and shape always vary subtly, giving us our own unique likeness.

Except for the mobile lower jaw (mandible), all the skull bones of an adult form a rigid, united structure. In infancy, however, the bones are soft at the joints and still growing. After a few years, though, these bones tend to fuse together – even though the bones of the rest of the body continue growing until adolescence. This means that children's skulls, and therefore their heads, are much larger in relation to the rest of their body when compared to adults (see *Proportions,* pages 58–59).

MATERIALS

Conté pencil

1 *The biggest form of the skull is the brain-containing cranium, which is a fairly symmetrical oval when viewed from the side. The mobile lower jaw together with the sloping upper jaw form a loose rectangle.*

2 *I have now added the eye orbit. Note also I have begun on the cheekbone, which turns and extends backwards from the eye orbit to the ear, and the temple, which is a slightly depressed oval within the larger cranial oval.*

3 *Having rounded out the cranium with shading and a little use of the finger, I added the upper jaw, which is part of the main skull, and the lower jaw, which is a completely separate bone that pivots on the cheekbone.*

The finished drawing
The front of this skull is fairly straight and upright. If you have access to a real skull, you may find many differences of emphasis and detail. Note also how large the cranium appears to be without hair.

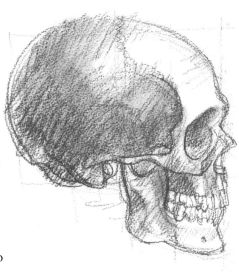

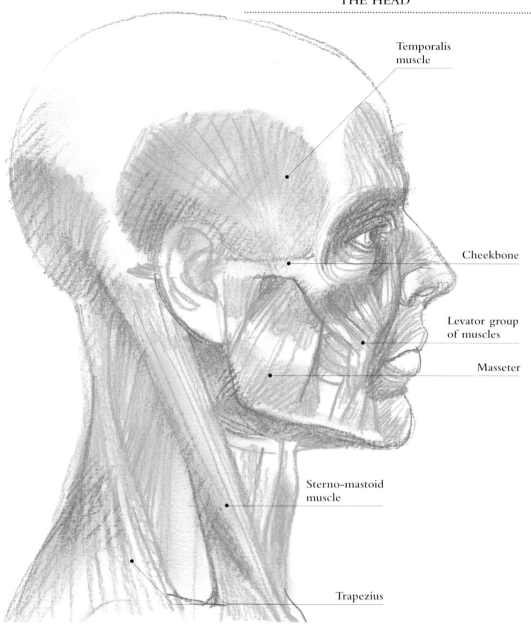

Temporalis muscle

Cheekbone

Levator group of muscles

Masseter

Sterno-mastoid muscle

Trapezius

Surface muscles

In certain areas of the head, surface form is determined by muscle rather than bone. The temporalis muscle helps to shape the side of the head, while the masseter and, to a lesser extent, the levator muscles give form to the face below the cheekbone.

In the neck, the muscles that take the strain of holding the head erect – the trapezius and the upper fibres of the erector spinae group (see page 65) – can be identified. The most prominent form here is the sterno-mastoid muscle, which connects the base of the skull just behind the ear to the inner end of each collarbone. It is especially noticeable when the head is turned to one side.

Changing your viewpoint

Viewing the skull from different angles emphasizes how small a part is occupied by the face: a fact that often surprises. In life, the facial features assume such importance that we tend to overestimate the actual size of the face and to diminish the size of the cranium.

Three-quarter view

This view of the skull shows the relative flatness of the facial area and the sharpness of the turn from this facial plane to the side of the head.

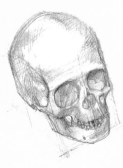

High three-quarter view

A higher eye-level view of the skull compresses the facial area into a very small and tight arrangement. The cheekbone becomes the dominant feature of the face.

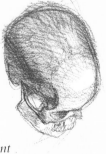

The plan view

The egg-shaped form of the cranium, narrowing at the front, is seen most clearly from above. The brow ridges and cheekbones widen the face and provide sockets for the eyes to be set wide apart.

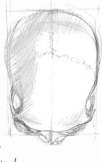

FACIAL FEATURES

THE DOMINANT FACTOR in determining how one face differs from another is the bones of the skull. The facial bone structure prominently shows through at the cheekbones, the jaw and the ridge of the nose. It determines the shape of the forehead and the brow ridges, and how they relate to the facial area. Furthermore, it establishes the extent to which the mouth area protrudes and the chin juts or recedes.

Bone structure also determines the positioning – as well as the form – of the facial features. It is important to note that an individual's facial characteristics are primarily established not by the features themselves, but by the distances between them – for instance, the exact location of the mouth opening and the set of the eyes. Of course, the bone structure allows infinite variations of shape and form in the fleshy parts of the nose and the mouth, the size and shape of the eyes and eyelids, and so on – but these factors are much less significant than the underlying skeletal structure.

MATERIALS

2B pencil

Oil bar

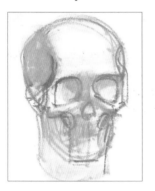

*1 This is a simple drawing of the proportions of a skull. I used an oil bar, which enabled me to overdraw the muscle and soft tissue.
First I put in the main outlines and, by smudging with my fingers, the principal areas of tones.*

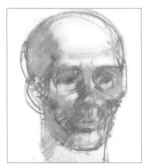

2 From the positions of the eye sockets and cheekbones, I could judge where the eyes would have been and begin to construct the form of the facial features.

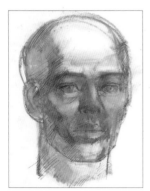

3 The bite line of the teeth suggested the placing of the lips, and from the emerging features I guessed that the fleshy part at the base of the nose might have been fairly broad.

The proportions of the face

To demonstrate the main proportions of the head and face, I placed a rectangle over two drawings of a 'normal' skull. Then I subdivided the rectangle into quarters and then eighths.

Side view
Look how small the facial area is compared to the whole skull – it makes up about an eighth of the area of the enclosing rectangle.

Front view
Note here that the eyes are only about halfway up the face, while the mouth is slightly below a quarter of the way up.

The finished drawing
This reconstruction is only one interpretation of the original skull. The point is that all faces built up on this particular skull will have a basic similarity, even though their feature details may be very different.

High viewpoint

Here, the top side of the inverted triangle is markedly tipped, showing how the line of the eyes has changed in this high eye-level view.

Note how the nearest side of the triangle is roughly parallel to the imaginary line that indicates the change of plane from the front of the face to the side plane. This always applies, no matter what viewpoint or what pose you choose.

The key triangle

A very useful guide to the proportion of the facial area is the triangle formed by joining the centres of each eye and the middle of the mouth. This not only helps with the positioning of the features, it also allows you to establish the orientation of the whole head from your chosen viewpoint. Inset: The key triangle indicates a normal eyelevel view, with the mouth plane very slightly forward of the eye plane.

Low viewpoint

Although the eye-line side of the triangle is again horizontal in this head-back pose, the other sides are much shorter, thereby making a 'squashed' triangle.

PRACTICE EXERCISE

IN THESE TWO FACIAL studies, I used the key triangle outlined on page 71. This is particularly helpful when you are at an angle to your model or when the head is not level. I have posed both the models in a three-quarter view, with their heads tilted slightly.

MATERIALS

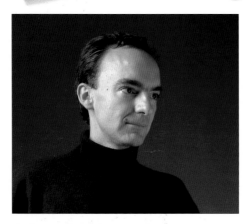

Charcoal

Pastel stick

I suggest that, as below, you use charcoal, which allows you to establish the construction lines of the triangle boldly in the knowledge that they will vanish as the drawing progresses. Alternatively, as I have done on the opposite page, use gouache so that you can cover up the triangle with opaque paint. Note that for emphasis in these exercises, I have drawn the key triangle very boldly – you may find that using small dots or ticks is perfectly sufficient.

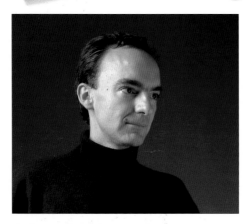

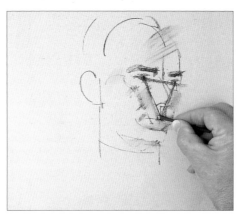

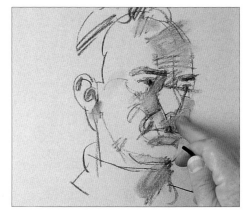

Selected pose
The lighting gives maximum definition between the frontal and side planes. Although the face is largely in shadow, I could still see details of the features.

1 *I formed the key triangle from the two eye centres to the third point in the middle of the lips. Note how the top side of the triangle slopes down to the right, revealing the tilt of the head.*

2 *Check the triangle as you establish tone. In particular, compare the top, which defines the width between the eyes, with the two sides, which define the height of the eyes above the mouth.*

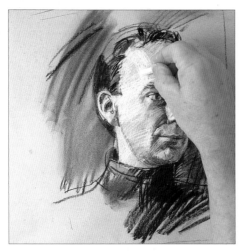

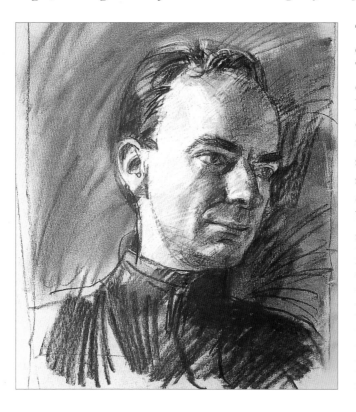

3 *Drawing on a toned board allowed me to use white Conté stick to reinforce the light areas on the side of the cheek and forehead. Don't be seduced by drawing too strongly with white; work up gradually to the brightest highlights.*

The finished drawing
To enhance the drama of the rather Rembrandt-like fall of light, I rendered the pullover with strong black strokes and darkened the background with smudged charcoal. In the final drawing, note how using the triangle has helped me to capture the slight tilt and twist of the head down to the model's left.

PRACTICE EXERCISE

MATERIALS

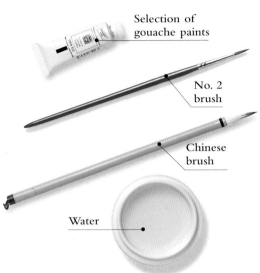

Selection of gouache paints

No. 2 brush

Chinese brush

Water

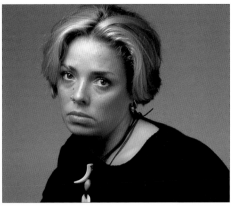

Selected pose
This time I arranged the model with front lighting and used a range of gouache paints in warm to cool colours, with lamp black and white.

1 *In a strong red, I drew the triangle and several other marks to indicate the prominent features. Inset: I started modelling the face using raw sienna with a touch of black and raw umber.*

2 *Carefully indicate the lower eyelids as they follow the spheres of the eyeballs. Then apply body colour across the forehead and the inner cheeks – these areas tend to form another triangle reflecting the inner one.*

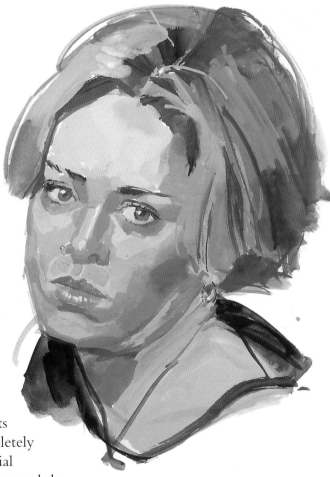

3 *I continued using body colour to model the face – note the slightly warmer colour on the extreme left to show the turn of the plane. Inset: Then I applied cooler colours in the shadow areas under her eyebrows.*

The finished drawing
The opaque tints have now completely covered the initial construction lines, and the point of the exercise – to show that a drawing can start with geometry and end with a face – has been demonstrated.

HANDS & FEET

*Hands and feet are notorious for being hard to draw. But with close
observation, a little understanding of anatomy and a fair amount of practice,
they should present no more problems than any other part of the body.*

HANDS ARE particularly expressive parts of the
body. In many portraits, simple hand gestures
are as important as the face in conveying mood
and character. It is essential, therefore, to render them
accurately. The way to achieve this is always to see the
hand and fingers as a single form. A big stumbling block
is that, as we know each finger is separate, we try to
draw them one by one. In most poses, the fingers will
actually be in contact with each other. Even when they
are not touching, try to imagine them webbed together
so that you can visualize the form that links them. Only
when you have established the overall form should you
start to distinguish between individual fingers.

Remember also that when a hand grasps an object, its
form reflects the volume of the enclosed shape. This
applies even when a hand is simply resting on an object.
If two hands are lying on top of one another, the top
hand will follow the form of the lower one.

The function and construction of the feet are entirely
different. But, as with hands, first try to capture their
overall form, and add the details later. Observe, in par-
ticular, the springy arch between the toes and the heel
and the sloping plane on top of the foot. You can see
from a wet footprint exactly how the foot makes con-
tact with the floor. Try to visualize this footprint when
drawing so the same contact is apparent.

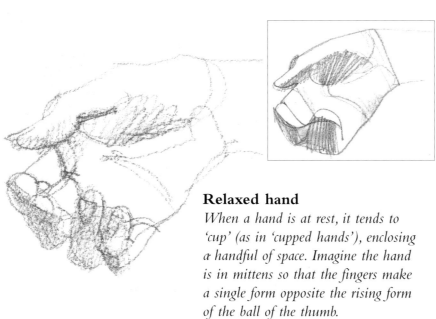

Relaxed hand
*When a hand is at rest, it tends to
'cup' (as in 'cupped hands'), enclosing
a handful of space. Imagine the hand
is in mittens so that the fingers make
a single form opposite the rising form
of the ball of the thumb.*

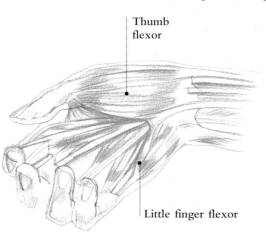

Thumb
flexor

Little finger flexor

Anatomy
*The hand is not just a
paddle with a row of fingers
attached. It is a complex
structure comprised chiefly of
bone and tendon — most
of which can be seen at the
surface. The two sizeable
muscles are the thumb flexor
and the little finger flexor on
the palm side.*

Enclosing hands
*Here is an obvious example of hands
reflecting the shape of the object they
are holding. A hand tends to take up
the form of an object, even if it is only
resting on it — assuming, of course, that
the palm faces downwards.*

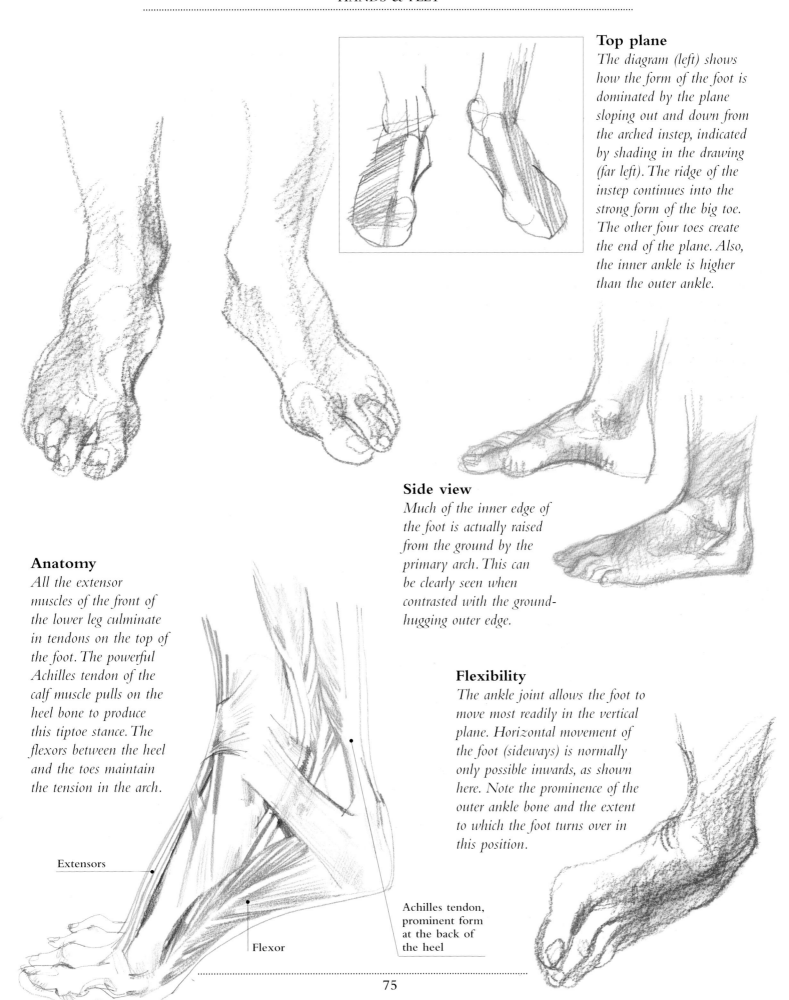

Top plane
The diagram (left) shows how the form of the foot is dominated by the plane sloping out and down from the arched instep, indicated by shading in the drawing (far left). The ridge of the instep continues into the strong form of the big toe. The other four toes create the end of the plane. Also, the inner ankle is higher than the outer ankle.

Side view
Much of the inner edge of the foot is actually raised from the ground by the primary arch. This can be clearly seen when contrasted with the ground-hugging outer edge.

Anatomy
All the extensor muscles of the front of the lower leg culminate in tendons on the top of the foot. The powerful Achilles tendon of the calf muscle pulls on the heel bone to produce this tiptoe stance. The flexors between the heel and the toes maintain the tension in the arch.

Extensors

Flexor

Achilles tendon, prominent form at the back of the heel

Flexibility
The ankle joint allows the foot to move most readily in the vertical plane. Horizontal movement of the foot (sideways) is normally only possible inwards, as shown here. Note the prominence of the outer ankle bone and the extent to which the foot turns over in this position.

PRACTICE EXERCISE

THE BEST WAY TO explore the feet's structure and form is to pose them in action. In this exercise, the standing model has her left foot flat on the floor in a supporting role, while her right foot is ready to take off, with only the ball of the foot and the toes in contact with the ground. Note how the left foot flattens out a little as it takes on the weight of the body: the arch becomes less pronounced, the curves of the pads are squashed down and, in fact, the whole foot becomes slightly wider.

The feet can be also arranged in the same positions with the model sitting down. This pose will cause some change in the form of the feet, as they only have to take a fraction of the body weight. However, it will be much more comfortable for the model, and will also reduce the pressure on you to work quickly.

For the hands exercise, I chose an easily maintained pose. One hand is at rest, in a typical semi-closed position, while the other hand almost droops over the wrist. It speaks of a person in a placid and relaxed mood.

MATERIALS

Charcoal

Kneaded eraser

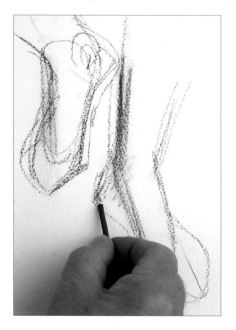

1 *I began by putting down the outline of the two feet, concentrating in particular on the strong form of the main arches. Then I indicated some of the major changes of plane; in the far foot, for instance, I have used tentative lines to indicate the protrusion of the ankle and where the main part of the foot meets the toes.*

2 *The model's left foot is planted firmly on the ground – the heel, the ball of the foot and the whole outer edge all make contact with it. On the inner side, the raised arch tensions the whole structure. Here, I have expressed this ridge by smudging the charcoal to indicate the changing tone of the sloping foot.*

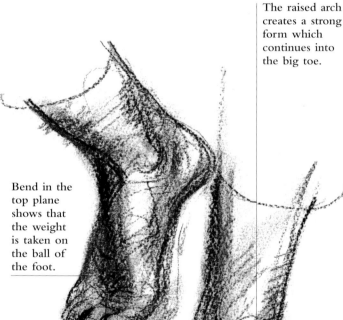

The raised arch creates a strong form which continues into the big toe.

Bend in the top plane shows that the weight is taken on the ball of the foot.

The finished drawing
As you complete your study, firming up the outline and detailing, be careful not to lose the strong overall form. Make sure that the plane of the top of the foot can clearly be seen to slope down to the outer edge, and that the ball of the far foot appears to be on the same ground plane.

PRACTICE EXERCISE

MATERIALS

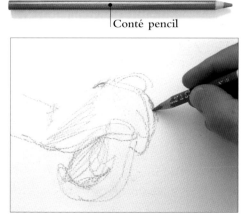

Conté pencil

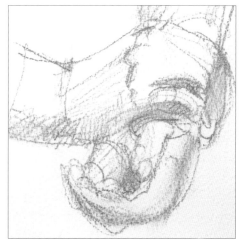

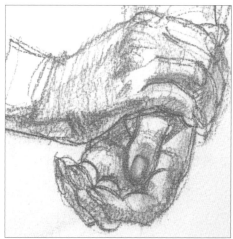

1 *These hands are at rest, the lower one cupped with the upper one curled loosely over it. Start by sketching in the overall shapes, treating the hands as though they were in mittens. I drew in sanguine Conté, which is not easily erased, but the early 'searching' marks can be covered later.*

2 *I began to differentiate the forms a little, marking the scalloped line of the knuckles and beginning to lift the third and little fingers of the upper hand from the 'mitten'. As you add specific shape, take care that you do not dissipate the original strong overall statement.*

3 *Now introduce divisions between the individual digits and begin to render their form. The knuckles of the first three fingers are more noticeable than that of the little finger. Also note the way the knuckles describe an arch.*

The finished drawing

In the last stage, I worked on the back of the upper hand, rounding and strengthening the form and generally increasing the contrast to accentuate the curl of one hand and the cupping of the other. It is very easy to go too far in adding detail and lose the essence of the pose – so always be prepared to sit back, reassess and re-emphasize.

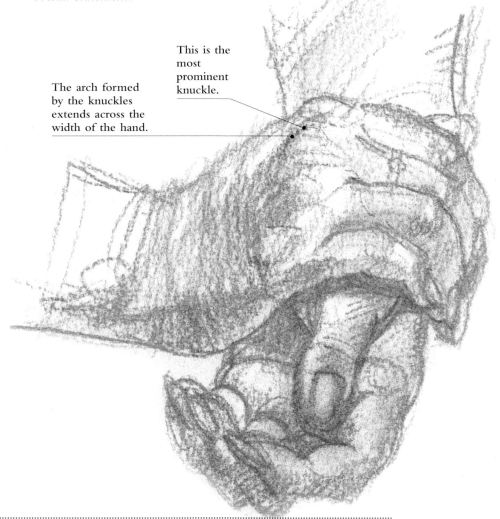

This is the most prominent knuckle.

The arch formed by the knuckles extends across the width of the hand.

BALANCE

*Having looked at human anatomy, it is a natural progression to consider
the ways that the body adapts to the weight shifts necessitated by
various poses and movements – in other words, balancing.*

THE MOST CRITICAL position normally adopted is that of standing on one or two feet. We perform this feat of balance without conscious effort, making minute adjustments determined by sensitive movements in the nervous system, to keep our body weight precisely positioned above the small contact area of our feet on the ground. Even when the surface of the ground is sharply sloping or uneven, balance is still maintained without difficulty.

Obviously 'standing' on the hands is even more difficult, and not often seen, but the mechanisms involved are essentially the same. In each case, by using the pull of muscles on the skeleton, the body must keep its centre of gravity directly above the point of contact with

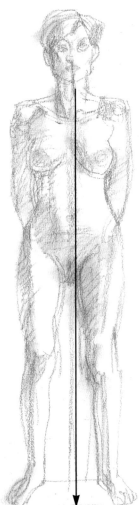

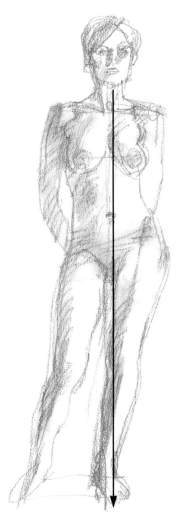

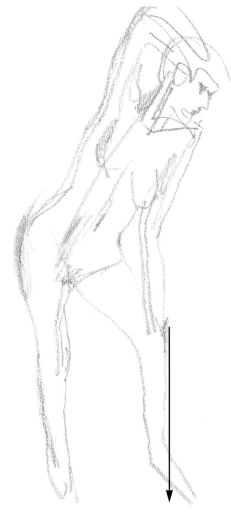

Equal weight on both feet
*In this position the figure is in
symmetrical balance, with an upright
spine. The head is erect on a straight
neck and positioned above a point
equidistant from both feet, indicated
by the vertical line from the centre
of the neck to the ground.*

Weight on one leg
*Here, the body weight is supported by
the model's left leg. Her pelvis has
tilted to her left, forcing the hip and
thigh bone to jut out. The whole upper
body has shifted sideways above the
weight-taking foot. The vertical from
the neck goes through the left foot.*

Propping weight on one leg
*The jutting hip suggests that the
weight is principally on her right. In
fact, the model has tilted her torso
away from this support and is propping
herself up with her left arm against her
knee. The body weight is transferred
through her left lower leg.*

the ground – that is, the feet (or the hands) – at all times. As artists, we have to watch these adjustments closely. Failure to do so will result in drawings in which the standing figure appears to be falling over.

As we have seen in the skeleton (see pages 60–63), the burden of weight is shifted from one leg to another by tilting the pelvis, bending the spine and perhaps counter-tilting the shoulders. But it is not always that simple. For example, to bend forwards, even though the weight may be equally balanced between the feet, the bottom half of the torso must be thrust backwards to counter the forward movement of the upper body. Search for every visual clue that's on offer to help you to see how the masses are balanced. To help discover how the weight is being distributed, draw a vertical line from the centre of the neck to meet the ground.

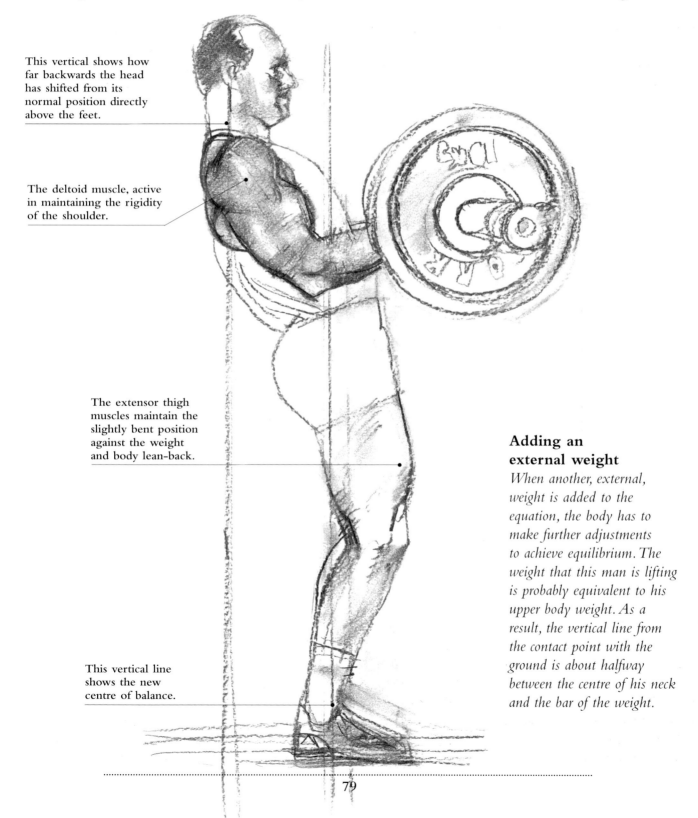

This vertical shows how far backwards the head has shifted from its normal position directly above the feet.

The deltoid muscle, active in maintaining the rigidity of the shoulder.

The extensor thigh muscles maintain the slightly bent position against the weight and body lean-back.

This vertical line shows the new centre of balance.

Adding an external weight

When another, external, weight is added to the equation, the body has to make further adjustments to achieve equilibrium. The weight that this man is lifting is probably equivalent to his upper body weight. As a result, the vertical line from the contact point with the ground is about halfway between the centre of his neck and the bar of the weight.

PRACTICE EXERCISE

SOME OF THE MOST exciting figure-drawing exercises involve balancing a figure by supporting it in unusual ways. Propping and leaning are comparatively gentle ways of doing this – the semi-reclined pose on pages 94–95, for instance, where the model is propped up by a locked arm, is near to being in relaxed equilibrium.

Suspension of some or all the weight is much more arduous and normally sustainable for only short periods of time. The pose here, for example, in which some of the body weight is hanging on the suspending arm, is really quite difficult to hold. However, it does provide a dramatic drawing, with the muscles of the torso and the hip area being particularly well defined. It is important to sense these dynamics, and to attempt to convey in your drawing the tensions and compressions through-out the body that hold the pose together.

MATERIALS

Selection of
Conté pencils

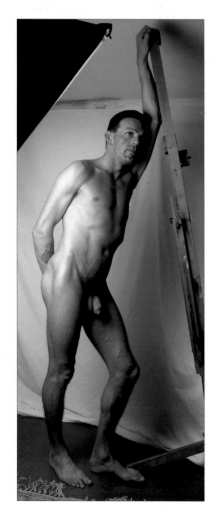

Selected pose
Note here how the figure is only saved from falling over by holding on with his left hand. To set up a pose like this, it is important not to be too ambitious. Suspending even a small proportion of the body weight from one arm will become very demanding for even the most athletic of models. So take time to find a position that your model is happy attempting, and be ready to accept that he or she will need frequent rests.

1 *First find the line that defines the angle of the trunk as it leans towards the support. I described this line in yellow-brown Conté from the top of the suspending arm down through the torso and the far leg. Then I tentatively positioned the head, the torso and the other bent leg. Note that the head is some way to the right of the feet, showing that the figure is off-balance and hanging from the arm.*

2 *The torso was rather tense in this pose, so I started to develop the form here first. Somewhat unexpectedly, there was very little pelvic tilt and compensating shoulder movement, although it is quite probable that another model in this pose might show different bodily movements.*

3 *I paid particular attention to the way the torso swings as it transfers the weight hanging from the arm on to the right hip and leg. Note that the pelvis is tilted up by the weight-taking right leg. I stressed this leg by smudging the crayon by hand. The right arm and the left leg are drawn very tentatively at this stage.*

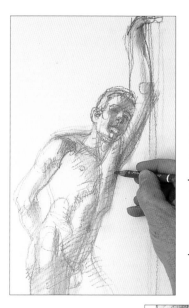

4 *I returned to the torso to define the clenched abdominal muscles. I introduced a red-brown Conté to strengthen the pectoral muscle, which is pulled up by the stretched arm. (When solidifying forms, take care not to weaken or lose the main movements.) I also used the red-brown to draw into the face and to define the turn of the model's left wrist.*

5 *As it was important first to establish the main action of the pose, I delayed finalizing the model's right arm until the end. Inset: I re-directed my attention now to the right leg, bringing out the form of the thigh muscle, using the red-brown Conté. Leaving the other leg loosely drawn emphasizes that it is relaxed and non-supportive.*

The finished drawing

As is often the case with males of athletic build, the weight shifts here are fairly subtle. If your model is a flexible female, you will proabably see much more movement between hips and shoulders. If you adopt this pose yourself, you will realize the great stress that is placed on the supporting arm. To express this, try to render the particular way the figure is balanced, as if it would topple but for hanging on that suffering arm. Throughout the drawing, check the line from the hand grip down through the arm, torso and the far leg.

This arm is totally relaxed and inert.

The pectoral is pulled up by the raised arm.

Taut abdominal muscles maintain the rigidity of the trunk.

The thigh musculature is well defined on the supporting right leg.

MOVEMENT

*Drawing a rapidly moving figure from observation is well-nigh
impossible, but this certainly does not mean you cannot make drawings
that convey a definite – and dramatic – sense of movement.*

UNLESS THE ACTION is very slow or continuously repeated, it is almost impossible to draw movement as it happens. A slow action, such as walking, can be studied by asking your model to pace back and forth. Pick an instant in this continuous action and draw one small part of it. Each time that particular point in the action is repeated, draw another bit, until you gradually build up a complete picture. Another way is to ask your model to adopt a stationary, mid-movement pose, but this may look stiff and unconvincing.

Probably the best, and certainly the most convenient, answer is to resort to film or photography. Replaying video or film can give you the chance to view an action repeatedly and build up a picture, while modern still cameras can freeze almost any action. One problem with the frozen moment is that it does not always convey a sense of movement: a blurred photograph may invoke a more convincing sensation of a figure in motion. I drew the sequence below from a series of photographs of a friend as he repeatedly ran past me.

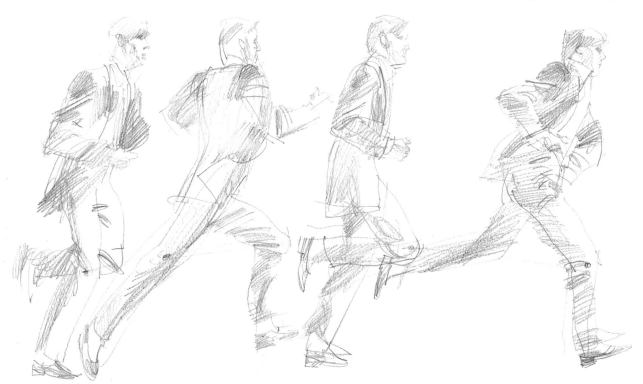

The moving figure
*Bipedal progress is a process of continuous
overbalancing and recovering just in time,
a marvel of controlled imbalance. The
nineteenth-century photographer Eadweard
Muybridge was the first to reveal the exact
sequence of movements involved in human
gait (right). With a system of linked cameras,
he took a series of photographs as a figure
walked, ran or jumped past the lenses.*

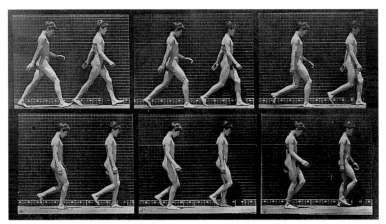

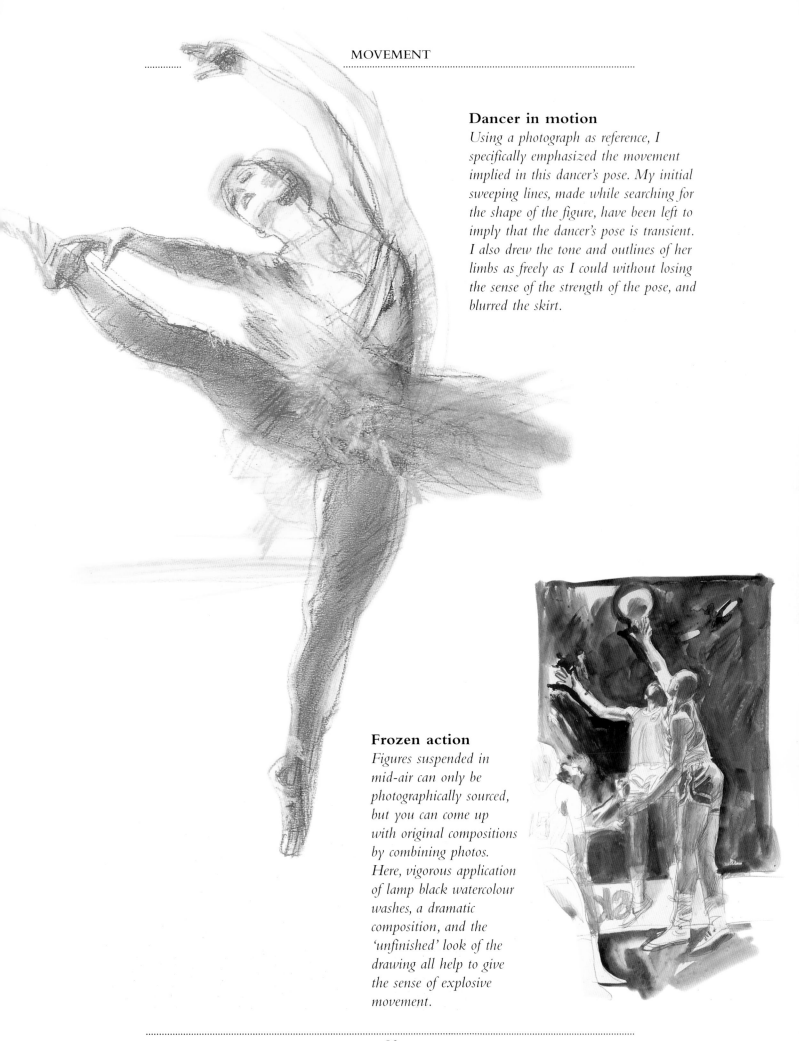

Dancer in motion

Using a photograph as reference, I specifically emphasized the movement implied in this dancer's pose. My initial sweeping lines, made while searching for the shape of the figure, have been left to imply that the dancer's pose is transient. I also drew the tone and outlines of her limbs as freely as I could without losing the sense of the strength of the pose, and blurred the skirt.

Frozen action

Figures suspended in mid-air can only be photographically sourced, but you can come up with original compositions by combining photos. Here, vigorous application of lamp black watercolour washes, a dramatic composition, and the 'unfinished' look of the drawing all help to give the sense of explosive movement.

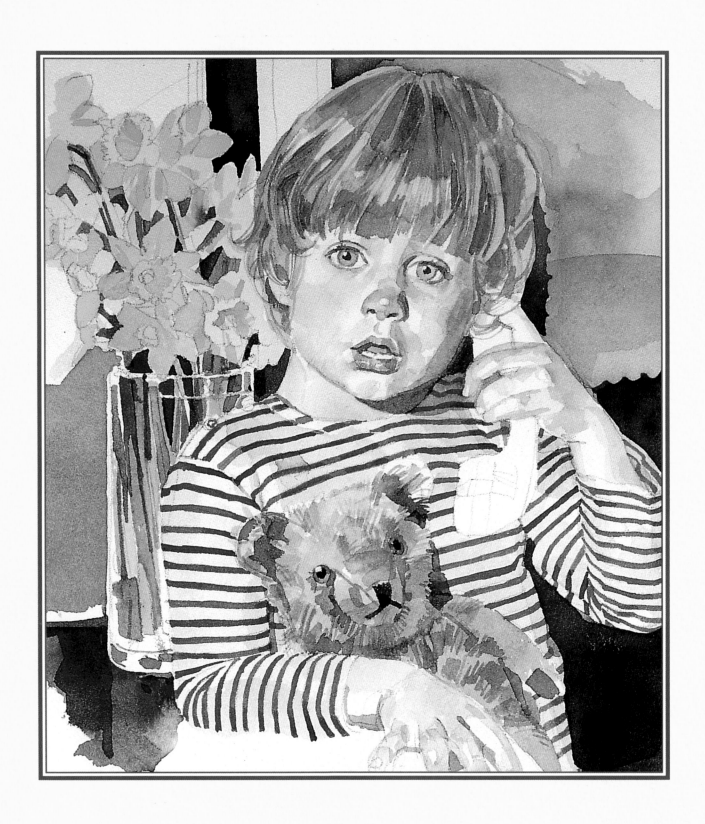

PROJECTS

QUICK POSES

Setting yourself a time limit forces you to draw boldly and freely. You take in the essentials of the pose rather than superfluous detail, and this will give you much more confidence when tackling longer sittings.

RATHER THAN GOING straight into a complete project, it is a good idea to spend the first half hour of any sitting drawing a few quick poses. This allows you to loosen up a little, get rid of your nerves and show you what positions the model naturally adopts and feels comfortable in.

Start with a 15-minute pose and then try to work down to shorter and shorter times. Always complete the whole figure, no matter how rudimentary it appears. In this way, you will learn to grasp the essentials of the pose immediately. During a full-length sitting, you can then add more subtleties to a basically sound structure.

Carry a sketchbook with you outside and capture people as they sit, stand and move. However cursory your sketches, they will lead you to better and more complete observation. Pencil is generally best for sketchbooks, but experiment with other media.

For times under 10 minutes, it is best to stick to just one drawing tool. For the 10-minute study, though, in addition to the blue chalk, I used red to bring forward the head and hands. And for the 15-minute drawing, I used sanguine and purple chalks, along with a white Conté chalk to bring out the highlights.

Four minutes: linear drawing

Even though time is short, make a drawing of the whole body. Ignore the details: instead, search for the main direction of the pose and put it down simply and positively. Don't necessarily go for the outline straight away: here, I drew in the curve of the spine first. Then I indicated the direction of the legs with loose lines, rather than worrying about their precise shape. Clothe the structure lines with fleshy contours only if you have time.

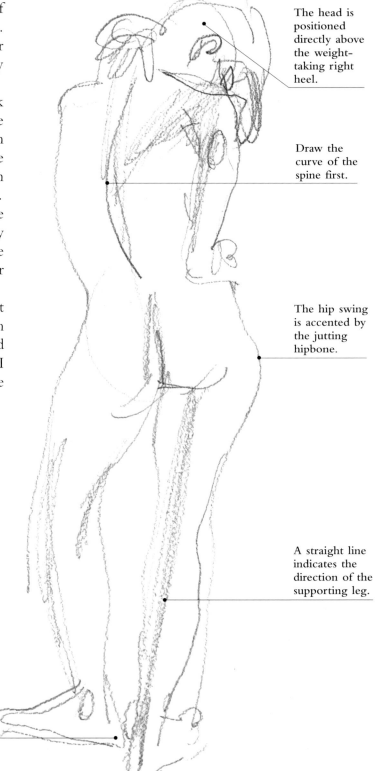

The head is positioned directly above the weight-taking right heel.

Draw the curve of the spine first.

The hip swing is accented by the jutting hipbone.

A straight line indicates the direction of the supporting leg.

Note the pattern of the feet and their contact with the floor.

Ten minutes: dramatic perspective

Do not necessarily add more detail in a longer study – spend the extra time observing the overall pose more carefully. You may want to choose a less familiar viewpoint. This figure, for example, is foreshortened because it is seen from a high eye level. There are some surprising correlations of different parts of the body. Note how the fingers of her right hand appear to reach her calf and are even in line with the toes of her left foot!

With little time, pay particular attention to negative shapes when positioning different body parts.

Check the alignment of different body parts across, as well as down, the model. Here, see how close the elbow is to the right knee.

Look for features that are coincidentally in a line – here, the line of the backbone passes through the middle finger to the weight-taking heel.

White Conté is used for highlights on the cheek and jaw-line.

Darker purple Conté emphasizes the hair shape.

Fifteen minutes: tonal drawing

In 15 minutes, it is possible to render the effects of light and shade, but you have to work rapidly. Scribble in the darkest shadow shapes first. Sanguine Conté chalk was used in this drawing, which can be rubbed and spread quickly, although it is not easy to erase. Re-establish the lightest areas by overdrawing with white Conté chalk, rather than trying to rub out.

Be conscious of this 'space left' – like a beach surrounded by steep cliffs, its shape helps a rapid assessment of the pose.

White Conté is used to refine the modelling and lighten the mid-tones on the rib cage and abdomen.

RECLINING FIGURE

*The reclined figure, especially on a chaise longue, is one of the classic
subjects of Western art. Try to find a pose for your model which embodies
a feeling of statuesque repose coupled with some interesting patterns.*

THE RECLINED FEMALE FIGURE has probably been drawn and painted more frequently than any other pose. Manet's 'Olympia', Velasquez's 'The Rokeby Venus', Goya's 'La Maya Nude', and Titian's 'The Venus of Urbino' are just a few famous examples that come to mind. It is not a pose often associated with the male nude – except perhaps in the work of Michelangelo. Traditionally, female beauty has been associated with passivity, while male beauty has usually been brought out in more active poses.

Whichever sex you choose, the human figure in repose – with head up and attentive, as opposed to flat out and asleep – presents a particular set of interesting problems for the draughtsperson. As the body weight is supported over virtually its entire length, there is little tension to be seen, except in the neck muscles holding the head erect. The torso relaxes like a sling between the supports of the pelvis and the shoulder girdle and/or arm props. These supports, in turn, adapt differently to a hard or soft surface, creating an interesting interplay between tense and relaxed, hard and soft forms. To achieve the formality that I felt the pose required, I made a careful pencil drawing first, over which I applied colour washes. I chose to use a rough-surfaced water-colour board, as it accepts watercolour well without the need for stretching and it also takes pencil.

MATERIALS

Selection of watercolour paints

Wash brush

Chinese brush

2B clutch pencil

Water

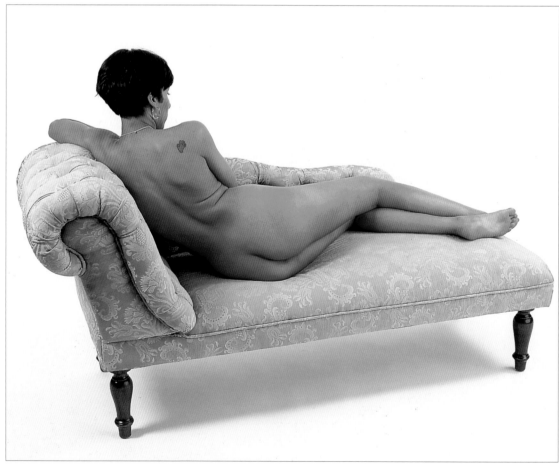

Selected pose
The hard surface of the upholstered chaise longue means that the shoulders and pelvis are supported firmly. Between these two props the trunk tends to sag, exaggerating the curvature of the spine, making an interesting interplay between hard and soft forms.

1 *Begin by mapping out the main forms of the figure and chaise longue. Then draw in the curve of the spine. Note how the curve is exaggerated as the body adapts to the unyielding surface of the chaise longue.*

2 *Next, lightly add areas of tone to the body with the side of your pencil – this will act as a useful guide when applying washes of colour later. Inset: Then work on the structure of the chaise longue, making sure it keeps pace with the figure.*

3 *Look at the areas of 'give' where the body comes into contact with the chaise longue. Here, I have made sure that the bottom thigh is not defined by a continuous outline – instead, I have altered the course of the line to suggest the way it sinks into the sofa.*

4 *As the drawing progresses, use stronger pencil strokes to define the turned-away head and to re-emphasize details, such as the ear and hair. Some suggestion of the fabric pattern and the detail of the wooden legs of the chaise longue should also be added at this stage.*

5 *Now add the first watercolour wash over the whole body. Begin with a weak mix, equivalent to the lightest area on the body. I used a Chinese brush (no. 5 or 6 Western brush), and a pale mix of raw sienna and a little cadmium orange.*

6 *When the first wash is dry, apply a base wash over the chaise longue. I used pale Winsor green with a touch of black. Again, remember that this wash must not be darker than the lightest tone of the material.*

7 *Then give the body a second, darker wash – in this case, raw sienna with a touch of black. Use your shading as a guide to the placement of this wash – the aim is to build up to the deep shadows by overlaying successive washes of paint.*

8 *Now look at your subject for the next darkest tone – in this demonstration, it was the shadow areas on the chaise longue. To render these, I increased the amount of black in my first mix of Winsor green and black.*

9 *The model's hair can now receive its first application of colour. For this wash, which represents the highlight colour of the hair, I used a mix of cobalt blue and black. (Highlights on dark, glossy hair often have a bluish tint.)*

10 *While waiting for areas on the body and upholstery to dry, paint the legs of the chaise longue. Using a wash brush and long, sweeping strokes, I also put in the initial wash for the floor shadow with a watery mix of cobalt blue and touches of black and cadmium orange.*

11 *Now add the stronger shadows to the figure, subtly varying the strength of your mix to enhance the modelling. Note, for instance, that the shadow area across the base of the spine is watered down by comparison with the small shadow on the edge of her right shoulder blade.*

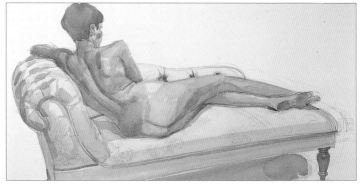

12 *Now reassess the light areas of the figure. In this picture, I judged that the light tones were not sufficiently differentiated. So I applied another wash, slightly darker than the initial body wash, over all the body – except for areas that I wanted to retain as strong highlights.*

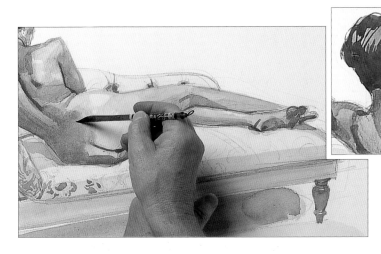

13 *Having refined the modelling in the light areas, I needed to adjust the shadows. I applied a burnt umber wash, cooled down with cobalt blue, over the upper shoulders and lower back. I also used this mix on her left buttock, where it disappears into the chaise longue, and on the soles of the feet. Finally, pattern was added to the fabric of the chaise longue and a stronger shadow applied on the floor. Inset: I applied a near-black wash over the hair, allowing some of the base colour to show through as highlights.*

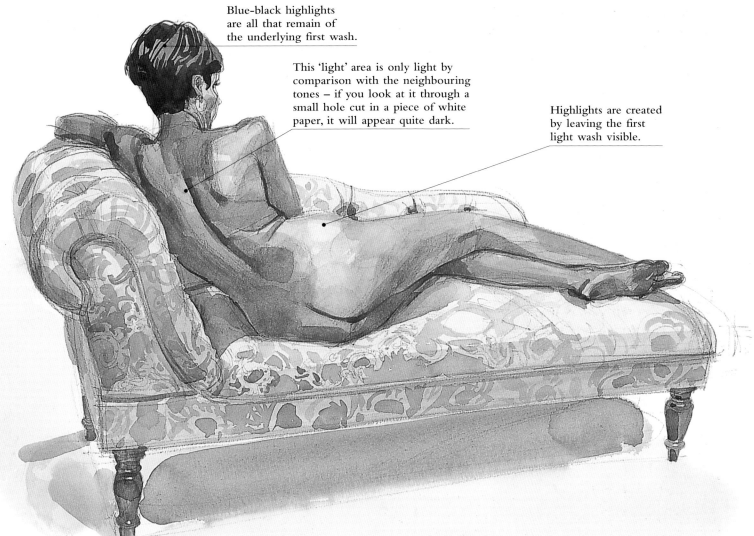

Blue-black highlights are all that remain of the underlying first wash.

This 'light' area is only light by comparison with the neighbouring tones – if you look at it through a small hole cut in a piece of white paper, it will appear quite dark.

Highlights are created by leaving the first light wash visible.

The finished drawing

The formal controlled appearance of the completed drawing is a result of the thorough preliminary pencil construction, which allowed me to place the washes with some certainty. As ever, one of the most difficult decisions in painting is when to call a halt to the proceedings. By attempting to give your painting a finished look, you can lose the verve with which you began. Often a quick painting made immediately after a longer study will still contain the same amount of information – but in a looser, livelier style.

SEATED FIGURE

*A model sitting on a chair must be the most commonly encountered
pose – some would say it is also the most boring. However, if you ring
the changes, the seated figure can be as exciting as any other pose.*

WHEN IT COMES TO drawing the seated figure, there is no need to stick to a straight-on, symmetrical pose, with the feet flat on the floor and the hands on the lap. Experiment with a variety of poses, and indeed a variety of supports, and you will find that every drawing session is a challenge.

Whatever pose you choose, it is important to view the figure and the chair as a single entity. Remember, the seated figure does not support itself. Having temporarily joined forces with a four-legged chair, your subject, in effect, becomes a six-legged figure. The chair legs take on the support role for the main weight of the body; the feet only take the weight of the legs and help maintain balance. Look closely for other areas where the chair provides support. If the chair has arms, they are likely to be supporting the human arms. If the pose is slumped a little, the chair back joins in the overall picture of weight distribution and support. For this drawing, I used Conté sticks and a grey pastel paper.

MATERIALS

Conté sticks

Naples yellow | Sepia | Sanguine | White

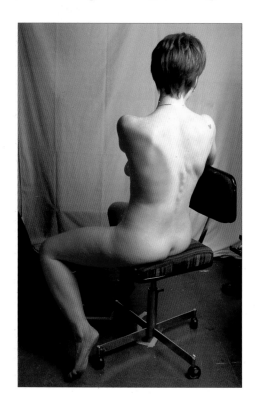

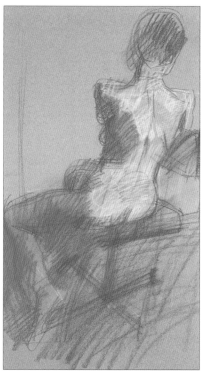

Selected pose
Note that the chair here has a central column which joins to a cruciform base, so the model is effectively supported in the same way as by a normal four-legged chair. This means that you must visualize the area on the floor which forms the base of the imaginary box on which she is sitting.

1 *Begin by tentatively describing the outline of the figure and the chair, re-drawing where necessary. Inset: Given that the grey paper is a mid-tone, you can work both from light to dark and vice versa. And with pastels, you can start establishing tones early, as modifications can be made as you go. Here, I am smoothing out the tone I have scribbled in for the chair back.*

2 *With this model, my attention was attracted to the prominent curve starting at her left shoulder and extending to her waist line. I emphasized it by building up the deep semi-circular shadow with the sanguine stick. This curve, in fact, provided the fulcrum for the whole drawing.*

The shoulder blades
are accented in
high-key tones.

A necklace
helps to define
the form of
the neck.

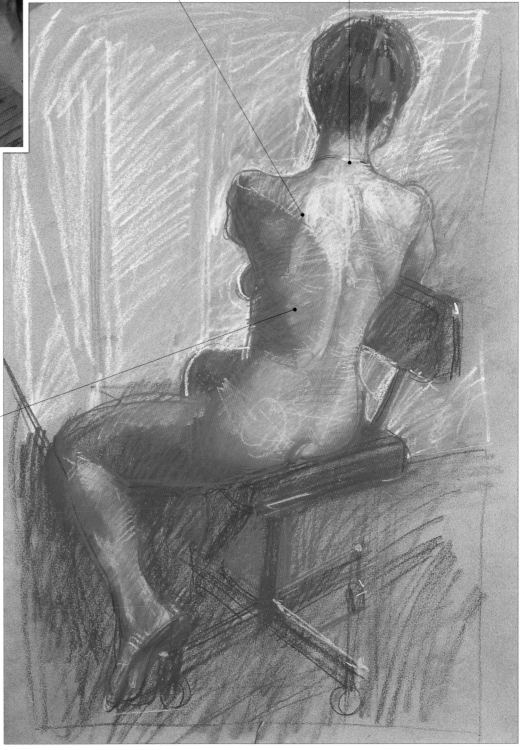

3 *Next, I scribbled in the backdrop with white and Naples yellow – this light tone helps to throw the figure forward. Then I concentrated on building up the tonal range on the figure, using the sepia stick on the dark areas in her hair and also on the semi-circular shadow on her back.*

A prominent
semi-circular
shadow provides
the key to the
model's pose.

The finished drawing

In the final stages the form of the back seemed too flat, so I continually restated the shoulder blades with white and Naples yellow. The near leg was not vital to the support of the pose, but the angle of thigh and calf interacts pleasingly with the angles of the chair. Also, I liked the arched foot of this leg, so I put some tension into the ankle by accenting the outer ankle bone and the Achilles tendon.

FIGURE IN TENSION

*The figure in tension, with the skin stretched across
flexed and well-defined muscles, is one of the
most striking of life-drawing poses.*

ALTHOUGH YOU MAY go into a figure-drawing session with a relaxed and easily maintained pose in mind, it is worth looking out for the more dynamic poses that your model adopts unconsciously during breaks or while moving from one position to another. Often these poses will be too unbalanced to be held for any length of time. Occasionally, though, you will see a somewhat 'difficult' pose that can, with a willing model, be comfortably held for short periods.

This is one of those poses. Although the hips and legs are comparatively relaxed, there is tension in the torso and in the supporting arms. As the arms are bent rather than fully extended, the pose was quite hard to hold and it was essential to rest the model frequently. Before a break, though, I made sure that the points where the body came into contact with the floor were marked so that the model could resume a similar position.

In this project, I used oil bars for the tones, and a graphite stick to draw into them. The beauty of oil bars is their ease of use: they need no special preparation and work on almost any surface – in this case, mount board. Furthermore, they are easily altered: a sweep of a rag wetted with white spirit spreads the oil colour and erases the graphite drawing on the oil-paint surface.

MATERIALS

Selection of
oil bars

Graphite
stick

Rag

Selected pose
The tension in this pose is mainly in the torso and arms. Note the prominence of the deltoid muscle of the shoulder, the triceps and biceps in the arm and the serratus anterior in the back.

1 *With a pale blue-grey oil bar, I sketched in the main shapes.* Inset: *Using a small piece of clean rag, I then smeared the colour to create areas of tone that followed the directions of the limbs and torso. If the oil paint is a little too dry to spread easily, use some white spirit on the rag.*

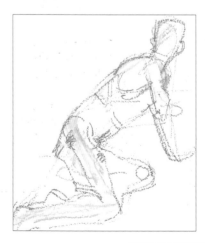

2 *The next marks were made with the orange oil bar, delineating more of the outline and the edges of the main changes of plane. Note how the bottom of the model's right foot lines up with the direction of his back.*

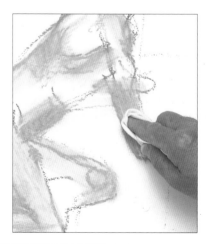

3 *Again I rubbed the orange lines together with a rag to make areas of tone. Although at this early stage the spreading appears to create rather abstract blocks of colour, I was continually referring to the light and shade on the model.*

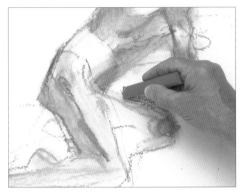

4 *I then used the graphite stick to re-assert the outline of the upper torso. (There was no problem in applying this, even though the oil colour was not totally dry.) Next I returned to the oil bar to re-work the shaded areas.*

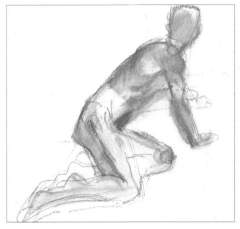

5 *I continued to alternate between the orange oil bar and the graphite stick, trying to capture the tension in the well-defined muscles.*

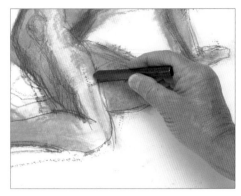

6 *Next, I introduced the raw sienna oil bar to refine the tonal range on the body. Together with the orange, it also helps to convey the warmth of the suntanned skin. Then I drew into the oil colour again with the graphite stick.*

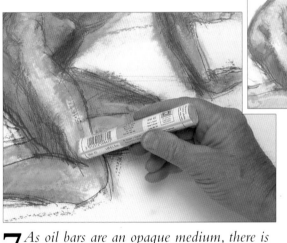

7 *As oil bars are an opaque medium, there is no problem if the whole drawing becomes too dark; just use a lighter colour to re-establish the pale areas. I used a Naples yellow for this, primarily along the thigh and hip, but also on the deltoid and triceps. Inset: To rub the paint and graphite together precisely, I abandoned the use of the rag in favour of my finger.*

The finished drawing

Note how the relaxed, rounded forms of the lower half of the body contrast with the tight, bunched forms of the upper torso and the tensely braced right arm. The action of the obscured left arm is revealed by the model's pushed-up shoulder.

Strengthening the arm draws attention to the slight elbow bend.

Highlights were established with Naples yellow.

A bold outline shows how the left foot wraps over the right ankle.

Loose outlines for relaxed forms.

STANDING FIGURE

As discussed in the section on balance (pages 78–79), the first thing to look for in the standing figure is how the weight of the body is being supported. Is it mainly over the right or the left leg, or somewhere in between? A vertical line (drawn or visualized) from the base of the neck to the floor is usually a good guide to the centre of gravity of an erect, balanced pose. Always check the position of the head in relation to the ground – even in an exaggerated, forward-bent stance, it is always a vital clue to the essence and balance of the pose.

To further make sure that your figure drawing is convincingly upright and firmly based, visualize the square or rectangle of ground on which the figure stands, and even sketch it in lightly.

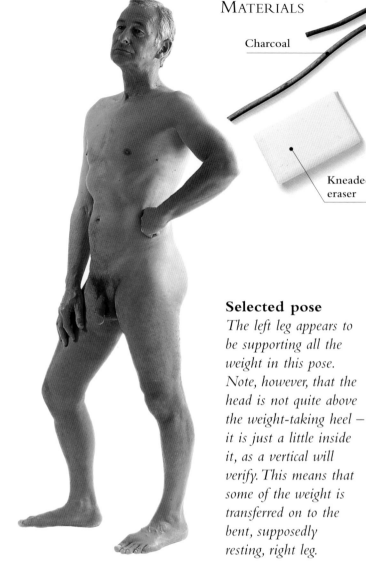

MATERIALS

Charcoal

Kneaded eraser

Selected pose
The left leg appears to be supporting all the weight in this pose. Note, however, that the head is not quite above the weight-taking heel – it is just a little inside it, as a vertical will verify. This means that some of the weight is transferred on to the bent, supposedly resting, right leg.

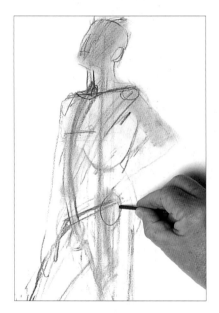

1 *First draw a vertical line to ascertain the head's position in relation to the floor. Then use firm construction lines for the curve of the trunk and the tilts of the pelvis and the shoulders. Note how I have established the body using both outline and areas of tone.*

2 *If this pose is to be convincing, it is vital to emphasize the supporting role of the left leg. Here I am smudging charcoal (almost along the vertical axis) to emphasize the leg's straightness and solidity.*

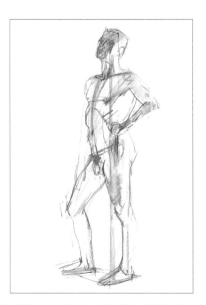

3 *Continue to establish the body until all the main shapes are in place and the figure is standing correctly. Note that the centre-of-gravity vertical is still evident. Now you need to clarify the figure further, especially in the pelvic area, and 'solidify' it by emphasizing the light and shade.*

4 *Work the charcoal over the front of the body and the left arm, which are both in shadow. Re-establish the lights with a kneaded eraser. Here, taking tone from the hip also helps move the joint forward.*

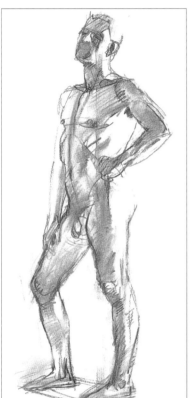

5 *Stop and assess your work. Here the forward arch of the trunk is a little exaggerated, but it is better to overdo a bodily movement than to understate it – especially if it makes the pose as a whole more coherent. Note how the original construction lines naturally soften and disappear during the process of applying and erasing charcoal.*

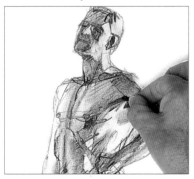

6 *In the last stages, I refined the originally observed movement and counter-movement. Here, emphasis was given to the way the model's chest (pectoral) runs into his shoulder, almost in one plane.*

The head is slightly tilted to help maintain balance.

An arc of dark tone denotes the main change from the front plane of the torso to the side plane.

The finished drawing
To complete the picture, I strengthened the supporting left leg and modified the over-simplified lower abdomen. Then you have to decide if you need to add detail to the toes, fingers and facial features. Ask yourself whether adding further detail will make your rendition of the pose stronger and clearer. If not, stop working.

Although the buttock catches the light, I have added more tone to distinguish it from the thigh.

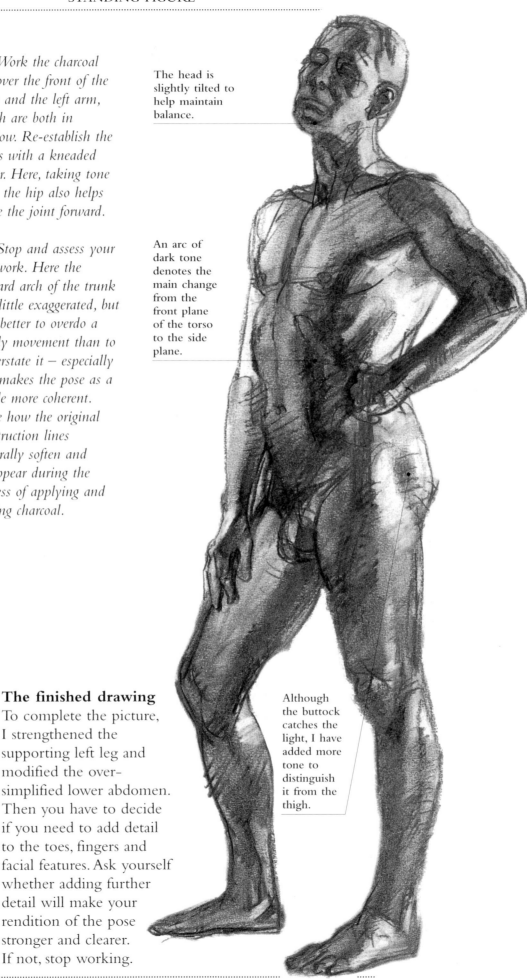

FORMAL GROUP

The ideal way to draw a formal figure group is to have several models posing at once. This, though, is a luxury that the amateur artist is unlikely to enjoy. The answer is to have one model take up a series of poses.

To DRAW A FIGURE GROUP from just one model, you must have some sort of guide to the positioning of each pose so that all figures in the final drawing have the appropriate space between them. Marking around the feet of each succeeding pose ensures that the model occupies a different space each time. If all the poses are standing, noting the position of the head against the background each time will give some guidance to relative size. If you choose a mix of standing, sitting, and lying poses, you will have to judge relative sizes by comparing head sizes or other features.

I based this project on a photograph of Auguste Rodin's famous sculpture, 'The Burghers of Calais', which features six standing figures in rather dramatic poses. It is not absolutely necessary to have a guide of this sort, but it can provide a useful starting point.

MATERIALS

Charcoal

1 *Charcoal is a good medium for complicated figure groups, as you can keep the drawing 'mobile' by making alterations easily. The first figure to draw must not be obscured by any subsequent poses – it will probably be the nearest one. Use both outline and smudged areas of tone to establish this figure.*

2 *Now ask the model to take up the second position. This should be a little offset and farther away from the first. Draw this pose so that it appears to be behind the first figure. Note how the strong outline around the back and buttocks of the first figure helps to establish the space between the two bodies.*

3 *For the third figure I positioned the model according to my reference, Rodin's 'The Burghers of Calais' sculpture. If you have no preconceived composition, just ask your model to adopt a pose in any position away from the previous footmarks. Then position your drawing by reference to these footmarks.*

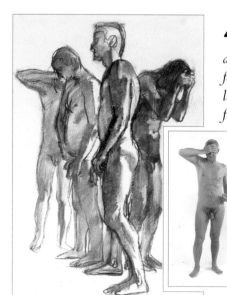

4 *The fourth figure was the last one I added to the tight foreground group; it was largely hidden by the first three. To distinguish it from the third figure and to give an impression of spatial recession, I drew it in slightly lighter shades of grey.*

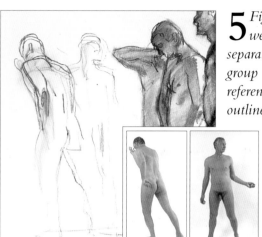

5 *Figures five and six were somewhat separated from the main group in my sculpture reference. I sketched an outline of the second-to-the-left figure first to give me some guidance for placing the figure on the extreme left.*

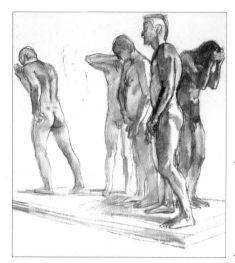

6 *Now that the group was nearly complete, I drew the plinth to define the floor area they occupy. You could go further and create a complete environment, with the figures posing on and against furniture.*

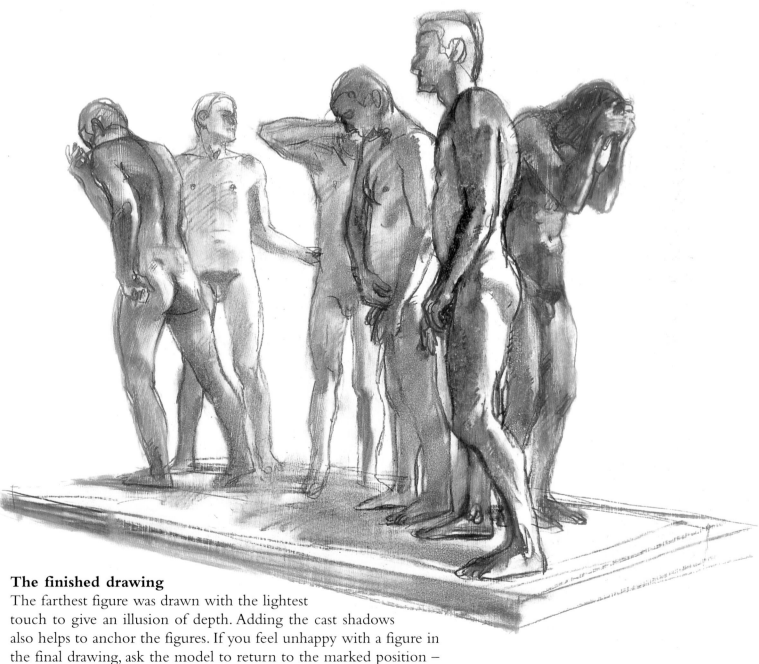

The finished drawing

The farthest figure was drawn with the lightest touch to give an illusion of depth. Adding the cast shadows also helps to anchor the figures. If you feel unhappy with a figure in the final drawing, ask the model to return to the marked position – then rework the charcoal, or erase it completely and redraw.

INFORMAL GROUP

*Interesting figure groups surround us in everyday life, and a good artist is always
alert to them. A family watching television, for instance, provides a group with a common
focus of attention and often a wonderful mix of relaxed and attentive poses.*

AS YOU CAN'T EXPECT an unposed group to remain motionless for very long, start by making a quick sketch of their positions. If you are drawing family or friends, you can then ask each individual in turn to hold their pose as you come to them in your main drawing.

Use your initial sketch also to check the composition as a whole. Consider the arrangement of light and dark areas and try to establish a focus of interest, the place where the viewer's eye will initially come to rest. This may be in the middle of the composition, but it is usually more exciting if it is placed off-centre. You could use an instant Polaroid photo instead of an initial sketch. But be warned – if your group is indoors, you may need to use a flash; you will be unable to use the photo as a reference for the light fall or tonal values.

MATERIALS

Selection of
watercolour
paints

2B pencil

No. 3
brush

Chinese
brush

Water

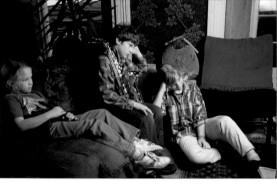

Selected pose

In this unarranged group, the centre of interest lies in a circle that includes the heads of the right-hand girl and her brother. The eye is then led naturally to the secondary subject – the stretched-out figure of the younger girl.

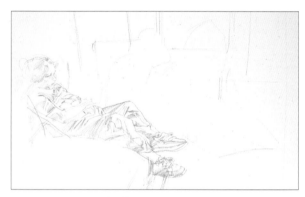

1 *Having marked out some guiding lines for your composition, you should ask the nearest figure of the group to hold the chosen position. Draw this figure as accurately as you can – I've defined the folds in the clothes and areas of tone on the head.*

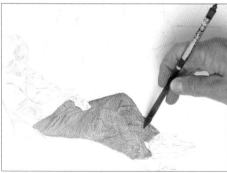

2 *You must now complete this figure before moving on to the next one. I first put down a pale wash on her face and arms, and then a preliminary light red colour on her trousers.*

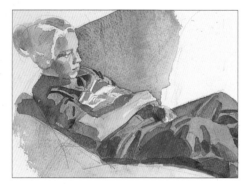

3 *After applying two – and in some places three – layers of wash, I decided that the first figure was finished. Remember that your first model is now free to leave the group, so make sure that you have finished.*

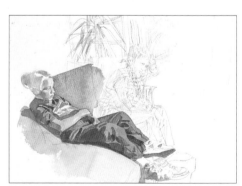

4 *Now move on to the next nearest figure and draw this one carefully. Also draw, as I have, any background that surrounds these two established figures, being careful to leave space for drawing the last figure.*

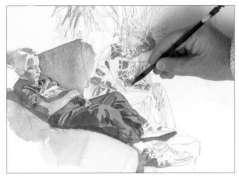

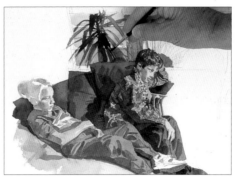

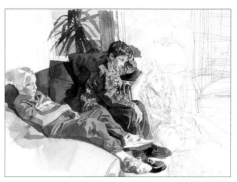

5 *Again, I applied colour first to the face and hands. Then, instead of the usual underlying wash, I painted the orange squares of the shirt, allowing the paper to show for the white stripes.*

6 *While completing the boy, I kept the background moving along. If you leave the background until the end, judgement of the tonal values becomes much more difficult.*

7 *The last figure and the rest of the background could now be drawn in pencil. When the last figure is fixed, think about how much more of the background you wish to include.*

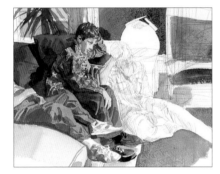

8 *To help me to judge the colour and tone of the well-lit girl on the floor, I first established the main tones on the right-hand side of the composition.*

9 *As you near completion, alternate between working on the last figure and co-ordinating the pattern and tone of the whole composition.*

The finished drawing

Finally, I put some dark blue-black on the wall to leave an olive-green pattern, added an indication of the pattern on the carpet, and deepened the tone of the chair. Try to persuade your models to regroup, so that you can make any final adjustments of tone or detail.

CLOTHED FIGURE

*Clothing often holds on to the body rather like an inelastic
second skin. To render it well, you must carefully observe
how it drapes and follows the body beneath.*

WHEN THE DRESSED FIGURE moves, the clothes
have to follow the body as best they can. The
tube of a sleeve, for example, remains
smooth and uncreased while the arm is straight, but as
soon as the elbow is bent, the cloth folds on the inside
and is stretched over the outside. The same thing hap-
pens to a trouser leg or any other relatively close-fitting
tubular form of clothing.

Each time the model rests, the folds will change in
their detailed shape, but their general response to the
new pressures will remain the same. Rather than just
copying the folds, try to become familiar with the over-
all patterns that the fabric assumes as it accommodates
to movements of the body.

Of course, in all but the tightest fitting clothes, some
parts of the fabric will respond to the pull of gravity
rather than the form of the figure – look, in this pro-
ject, at the end of the trouser legs and the sides of the
jacket. This aspect will be explored further on page 104.

MATERIALS

Bamboo
pen

Selection of
coloured
waterproof inks

1 *I started this drawing
by setting up the main
shapes of the head with
watery yellow and orange
ink. It is prudent to use
light dilute inks first:
although they cannot be
erased, they can be overlaid
with stronger colours as you
make corrections and build
up the forms.*

2 *Continuing with watery
ink, I developed the
head a little more. Ink of
this dilution may form
blots; mop them up with a
tissue. As you become more
confident, begin to introduce
more naturalistic colours –
test their strength first on
scrap paper.*

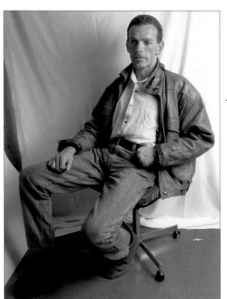

Selected pose
*To attain a pose with
a good contrast
between stretched and
folded fabric, it is best
to have your model
sitting down, with
arms bent. Here, look
at the lines of tension
that run from the
elbow, and the way
the jeans are smooth
across the tops of the
thighs, but have
'collected up' along
the sides.*

3 *Before finalizing
the head, map
out the upper body. I
did not indicate the
legs because I
wanted to change to
blue inks for the
jeans – but I made sure
there was enough space for
them!* Inset: *Now I
introduced brown and black
for the jacket. Note the way
the fabric stretches over the
outer edges of the shoulder
and elbow, but creases inside
these points.*

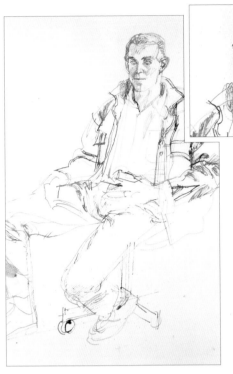

4 *I could now 'see' the entire pose clearly enough to draw in the legs with dilute ink that would permit changes.* Inset: *I returned to the upper body and head, building up the forms with darker ink.*

5 *After checking the negative shapes between the legs and the chair, I reinforced the shapes of the jean material. As with the jacket sleeves, the fabric of the jeans adapts to the model's bent legs by stretching and folding. Try to identify the main points of tension and selectively render them.*

The finished drawing

The final step was to put in the feet and chair supports. To attain the right perspective here, look closely at the points of contact that the two feet and the visible chair supports make with the floor. Then try to envisage the two-dimensional shape these points describe. Throughout this exercise, you should find your drawing style imitates the tensions and slacknesses you see in your subject. Hold the pen firmly to delineate the taut folds, but loosen up a little as you describe the relaxed fall of the fabric.

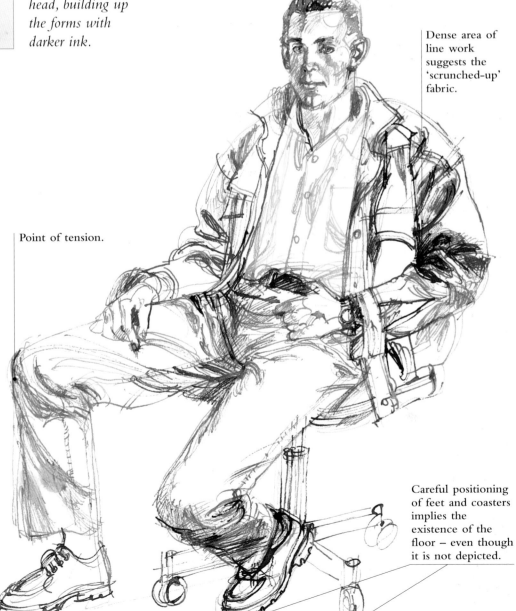

Dense area of line work suggests the 'scrunched-up' fabric.

Point of tension.

Careful positioning of feet and coasters implies the existence of the floor – even though it is not depicted.

LOOSELY CLOTHED FIGURE

*Like tight-fitting clothes, looser garments adapt to the
bending and twisting of the underlying body – but they also respond
to the downward pull of gravity.*

YOU CAN CREATE some really striking images by clothing your model in flowing, loose-fitting garments. When the fabric falls freely, the folds will be straight, acting as plumb lines defining the vertical. If the garment falls as far as the ground, it collapses in folds and forms. The exact appearance of this 'collapse' varies according to the type and weight of the fabric, and you must take account of the way different fabrics behave. Some cling silkily to the skin, some seem quite reluctant to fold, while others drape gorgeously from the body, almost with a life of their own.

Try to 'feel' these qualities and express them in the way that you draw. This means looking intently for the patterns of folds that different fabrics adopt, both when they are under tension from the figure and when they are released to fall and fold freely. Set up a pose that makes the most of the characteristics of loose clothing by allowing some of the garment to fall freely in straight folds while other parts are folded in upon themselves.

MATERIALS

Selection of
Conté pencils

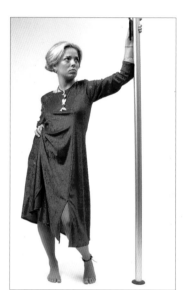

Selected pose
I set up this pose to attain a contrast between the bunched-up material stretched across the body and the wonderfully loose fall of the skirt. For a more extreme demonstration of the pull of gravity, try wrapping a bed sheet around your model.

1 *When working on toned paper, the preliminary marks can be made with a light colour. Here, I chose a pale-cream Conté pencil, which showed up well initially but would be covered as the drawing progressed.*

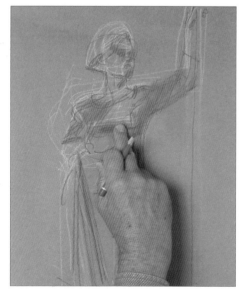

2 *I started to draw into the face with burnt sienna and into the dress with a pinkish red. Finger smudging helps to spread the colour and eradicate the structure lines underneath.*

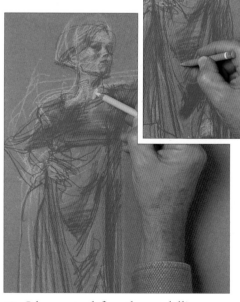

3 *I began to define the modelling on the face with yellow. Establish the set of the head early, as it is important to the whole balance of the standing pose. Inset: With pale pink, I then delineated the fall of cloth.*

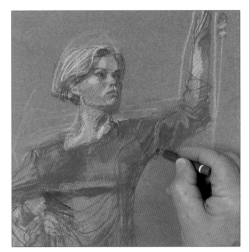

4 *Next, I emphasized the pull of the cloth across the model's breasts with purple. I also used this colour to draw into the tight folds of the stretched-up arm and describe the loose semi-circular folds over the stomach area.*

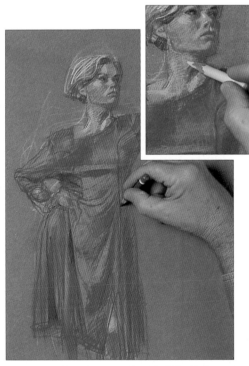

5 *Now for the wonderful fall of the skirt. When you see a pull as positive as this, show it by drawing boldly, as though you were trying to drag the cloth earthwards with your crayon. Inset: Finally, I refined the modelling on the face with pale pink.*

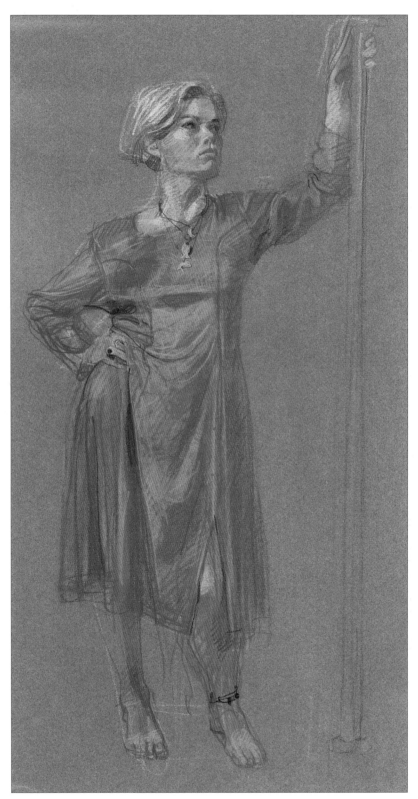

The finished drawing
Note that the position of the model's right arm has changed from the set-up photograph. This often happens – a model rarely returns to exactly the same position after a rest break. It is not a matter of major concern so long as the main thrust of the pose remains constant.

FIGURE IN A SETTING

*Drawing a figure in a setting takes a little planning: you
have to consider not only the pose, but also the way it forms an
overall pattern with the surroundings.*

BEFORE STARTING TO draw a model in a setting,
you should take some time to try out a few dif-
ferent arrangements. Ask the model to take up a
pose in which she feels comfortable. Look carefully at
the shape her body makes relative to her environment.
If the composition appeals to you, commit it to mem-
ory or photograph it with an instant Polaroid camera.
Then ask her to try another position, or simply let her
move about slowly until you say stop. Do this until you
are happy with the set-up and the model feels that she
can retain the pose in a relaxed manner.

It is very difficult to define exactly what constitutes a
good composition. A helpful aid is a viewfinder, made
simply by cutting a rectangular hole into a piece of
cardboard (see page 47). This isolates the composition,
forcing you to consider the arrangement of shapes
within the frame. Look at all the shapes – the spaces as
well as the volumes. Also try half-closing your eyes to
help you see the pattern of light and dark.

For this project, I chose a warm beige pastel paper,
which harmonizes well with the light flesh tones as well
as providing a good contrast with the cooler colours.
You need quite a large range of coloured pencils, espe-
cially in the warm colours: creams, tans, oranges, pinks
and reds. Also include black, some dark blue-greys and
browns, to give you possibilities for intermixing.

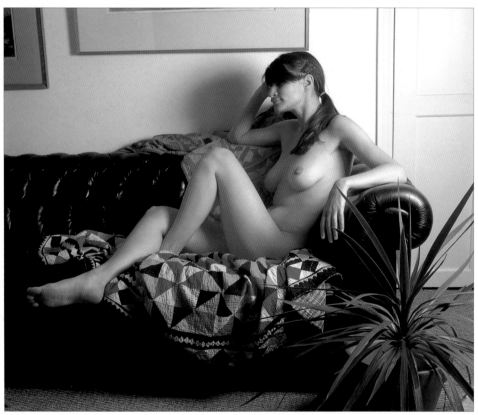

Selected pose
*After trying several positions, I finally settled on this set-up. I
particularly liked the interaction of the triangles made by the model's
arms and legs and with the pattern of the fabric. Note also the way
the bottom of the picture frames, the door and the potted plant help
to direct attention to the model in the middle of the composition.*

MATERIALS

Selection of
Conté pencils

1 *When you include the background
to the figure, it is essential that first
you map out the whole composition.
Use a light colour to do this – here, I
used a raw sienna colour that could be
easily obliterated by later drawing.*

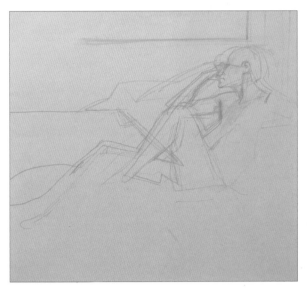

2 *For the first 15 minutes or so, keep the drawing quite abstract. You should only be concerned with establishing and modifying the distribution of the main elements of the composition. Look for the various triangles and the 'shapes left', rather than worrying too much about whether you have 'caught' the look of the model.*

3 *When satisfied with the general arrangement, start on the more detailed description of the model. I prefer to begin this around the head and neck area. I used dark grey Conté to make an initial statement of her hair.*

4 *I moved down to confirm the position of the model's legs. Widen your vision regularly, to check that your detailed work is consistent with the proportions of the whole figure.*

5 *I further defined the upper body and neck area with the raw sienna coloured pencil. Carefully relating shape to shape, I continued down to the breasts and shoulders.*

6 *Here, I added a little darker brown to the base of the neck and rubbed it in gently with my finger to create an area of tone.*

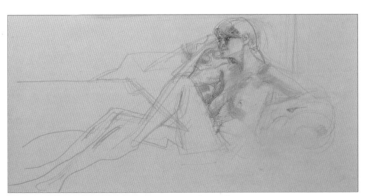

7 *Rubbing together some of the shading lines unifies the tones. If something is awry, you can correct it by redrawing. Try to avoid rubbing out. I used pale yellow Conté to begin modelling the breast and to capture the cooler local colour. Light pink was applied on the warmer skin tones.*

8 *I strengthened the form of the neck by drawing into the shadow with burnt sienna. Inset: I applied pale grey in a series of strokes over the burnt sienna, and to the plane of her chest, to cool the colour down. The resulting colour is mixed in the eye, not by rubbing together.*

9 *Do not proceed too far with the model's form before starting on the immediate background. Here, the pattern on the cushions was drawn in.* Inset: *Introduce darker colours gradually as you become sure of the relative proportions of the main elements of the picture. I brought the head and upper body almost to a finished state, while still reassessing and comparing shape against shape.*

10 *Now the drawing begins to work outwards again, establishing the form and something of the tone and colour of the sofa arm. The pencil used here was a dark blue-grey – I saved the black for final emphasis.*

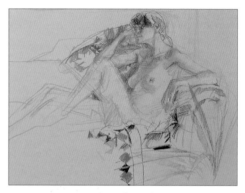

11 *As the sofa arm becomes stronger, also solidify the model's arm. The aim is to convince the viewer that the arm is really supported by the sofa. Remember that, in a sense, they are both part of the same form.*

12 *I drew in the diamond pattern of the quilt quite boldly. Accurately drawing the distortions in the rows of triangles, the pattern within the pattern, helps you to capture the form of the sofa.*

13 *Remember that the model and the sofa are interdependent, so keep moving your attention from one to the other. Stand back from the drawing frequently and check that everything is coming together.*

14 *By now you should be approaching the outer edges of the drawing and beginning to fill out areas that are only sketched in. Do not, though, take anything for granted – even while working on the form of the foot here, I was constantly standing back and checking its position!*

15 *I worked up the back of the sofa to help define the shape of the model's legs. The buttoning produced a series of six-sided regular raised forms, each with the same pattern of tones. Note that I am resting my drawing hand on my left hand to avoid smudging the foreground.*

16 *I was now reaching the 'when-to-stop' decision. A strong pattern on the cloth may overpower the figure, so I just detailed the patches close to the model with white and grey.*

17 *I strengthened some of the shadow areas with dark brown and brought out the pattern of the pink leaves of the plant against the sofa with black Conté.*

18 *Now stand back to see if any final lights are necessary. I added a little light pink to the girl's fingertips and some white highlights to the sofa arm.*

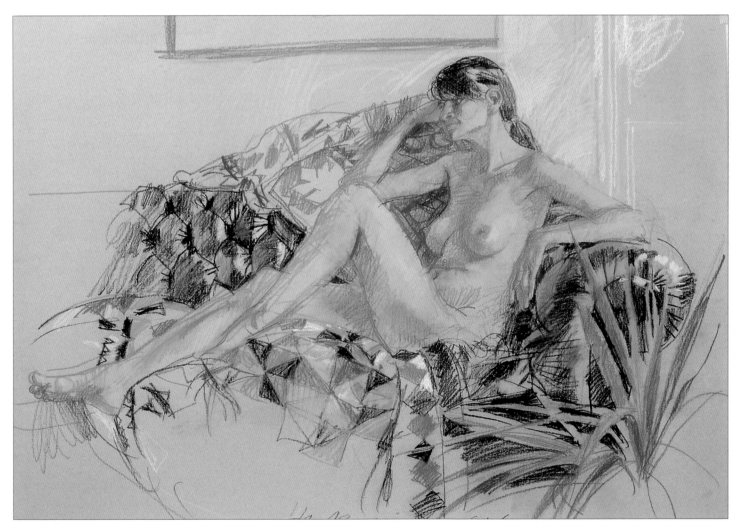

The finished drawing

When drawing a figure in a setting, it is imperative that you keep working up all parts of the drawing. It is remarkably easy for one element – for instance, an arm or a leg – to get out of phase with the rest of the drawing if you allow your attention to rest exclusively on it for too long. I have allowed the drawing to tail off towards the left; this focuses the attention on the upper body and head, with its interesting interplay between the shapes and colour of the model and the pattern and textures of the sofa and its coverings.

CHARACTER & EXPRESSION

Once you have reached the stage where looking for structure, form and proportion has become second nature, you can allow some emotional responses to your model to creep back into the picture.

IN ORDER TO SEE and draw objectively, I have stressed the necessity of eliminating your emotional, subjective and pre-programmed responses to what you are drawing. This approach will, to some extent, reveal individual character – in as much as it resides in the intrinsic form and shape of your model. But now you can change the emphasis a little and allow the living person to shine through.

Most, but not all, of this individuality you will find in the face, where over time habitual expressions become permanently etched. But also look for the myriad other clues to character: the way people sit and stand and wear clothing; their typical demeanour; how they place their hands; and whether they look down diffidently or boldly straight into your eyes.

The human face is capable of an astonishing array of expressions: some of them declare unmistakable emotions, others are very subtle. However, very few remain in place for long, so it is not easy to draw them. Only those that are habitual and do not involve tightly clenched facial muscles remain long enough, or recur frequently enough, for you to draw from life. However, you can learn a great deal about the more volatile expressions from photographs or watching actors.

Using the setting
One of the best ways of conveying character is to draw your sitters in their own environment – not in a bare drawing studio. This man, who is a fisherman and lifeboat coxswain, sat for me amongst his treasure-trove of memorabilia. All the significant events of his life seemed to be represented here in some form or another. It would have taken a long time to draw all the artefacts, but I included a few of them in a pleasing composition around his head.

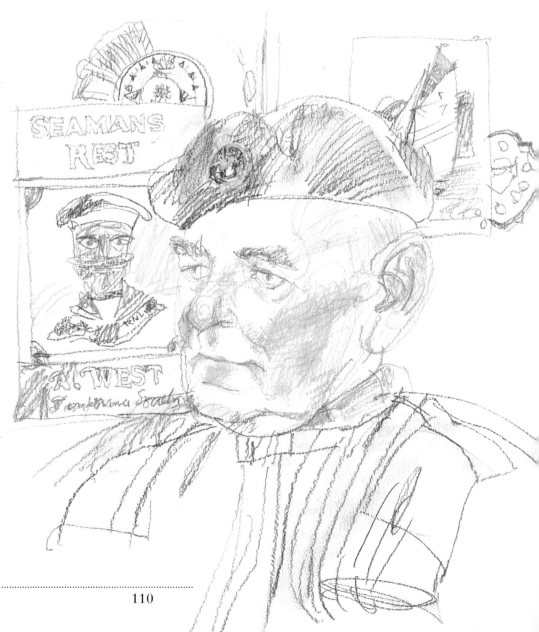

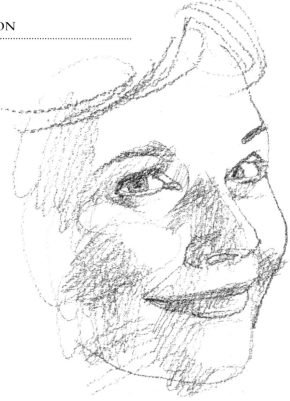

Smile or grimace?

Tiny alterations make all the difference to an expression. These two drawings were made from the same reference but show contrary emotions. To change a grimace to a smile may involve nothing more than a little widening of the mouth and a slight closing of the eyes.

Closed-mouth smile

A closed-mouth smile tends to pull the mouth upwards at the corners into a smooth curve. This is rarely the case when the teeth are showing. In this drawing, the characteristic bunching of the cheek muscles has not closed up the eyes as much as usual.

Square-mouth grimace

The 'square' mouth is usually an indication of anger or involvement with a physically demanding task. The furrowed brow, here resulting from concentration, can contribute to many other expressions as diverse as astonishment, anxiety and horror.

Comic expressions

The combination of a distinctive face and volatile emotions can produce an array of facial contortions. Analyze what is happening to each feature to produce the complete expression.

PORTRAITURE

*A good portrait is not just an accurate record of the arrangement of
facial features and body parts; it should also tell you something about
that more elusive quality – the sitter's character.*

THE CHOSEN SITTER for this project should have a distinctive or expressive face – one that ideally seems to tell you something about the person beneath and demands a second look. Old people, for instance, often have faces that seem to tell of the life they have lived. A younger model may have a dramatic haircut or exotic jewellery that gives a telling insight into their personality.

MATERIALS

2B clutch pencil

Do not necessarily restrict yourself to drawing only the face. Part of the character of many sitters is in the way they deport themselves or in their choice of clothes. In these cases, including the whole figure will better convey the personality of your model.

At the start of your drawing, ask your sitter to select a spot to look at. He or she can then return to this mark whenever you are working on the face. Similarly, as long as the main pose is held, allow your sitter to move any body parts that you are not concentrating on. Talk to your model too – you should be rewarded with a lively expression, rather than a glassy stare.

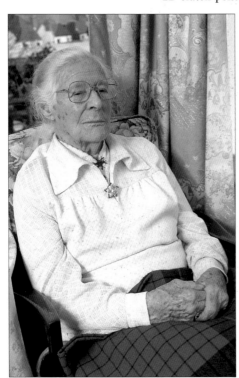

Selected pose
The first requirement for a successful portrait is making sure your model is comfortable. This lady is in her favourite chair where she regularly relaxes to read, chat, watch television or look out of the window.

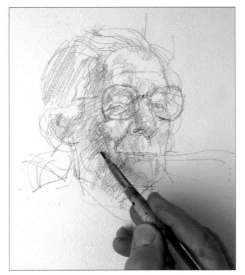

1 *Here, I started the head without mapping out the rest of the body. This is rather risky, but I made sure there was plenty of room lower down the paper. I quickly established the three corners of the facial triangle – the two eyes and the centre of the mouth (see Facial Features, pages 70–71). Inset: Next, I defined the spectacles which help to reinforce the frontal plane of the face.*

2 *While the front of the face was well-lit, the side plane was in quite deep shadow. This gives you the chance to use strong tonal changes to help create a convincing impression of solidity. Pay most attention to the line where the tone changes, rather than the overall strength of the shadow. After putting some detail in the hair, the head was more or less finished, so I moved outwards to the shoulders and chair back.*

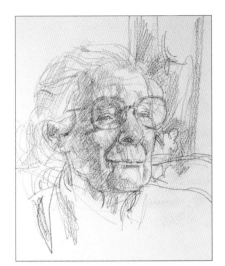

3 *Next, I added pattern and tone to the curtain to help bring forward the model's lit face. Now you can work down the body, using the pencil freely and incisively. Continually check the proportions of the body against the head.*

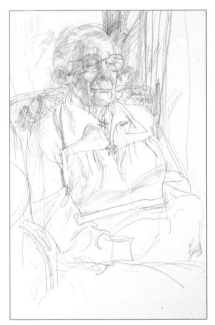

4 *For the clothes, I used crisp, strong lines for the folds and lighter, freer marks to indicate the shading. Adding the pattern of the chair helps to define the outline of the shoulders.*

A crisp edge to the shadow tone helps to convey the fall of light.

Dark background tone helps to throw the face forward.

Folds in the blanket suggest the weight of the hands.

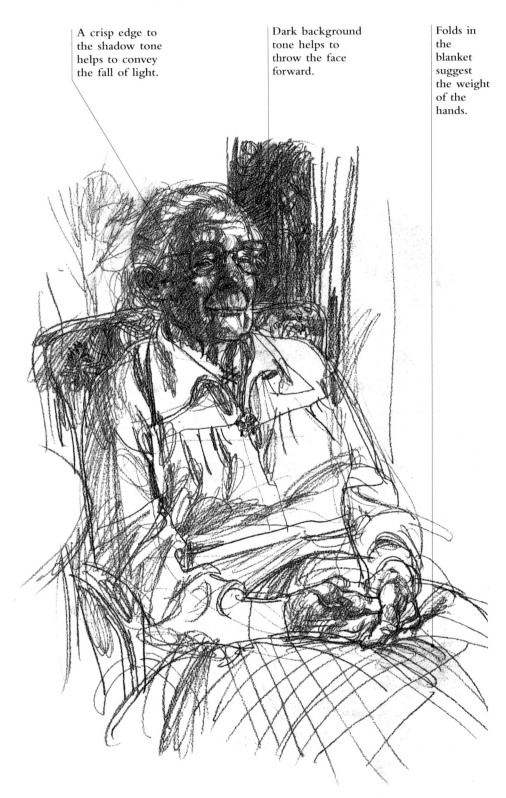

The finished drawing

Last of all, I drew her hands resting in her lap. You should pay particular attention to old people's hands: veins, bones and tendons are often very prominent. Also look at the way the hands at the bottom of the paper balance the head at the top, and help stress the strong diagonal of the composition. I drew the folds of her knee blanket to suggest the weight of her hands and arms.

SELF-PORTRAITS

EVERY ARTIST INTERESTED in the human face draws him or herself at least once. For some, the subject becomes an obsession – Rembrandt painted hundreds of self-portraits during his lifetime, recording the ravages of time with devastating honesty.

In many ways you are your own best sitter: you begin with some knowledge of the subject, and you always have a model available! But there are a couple of problems. Firstly, the view you have of yourself will be the reverse of what everybody else sees. Secondly, your viewpoint tends to be rather limited – you are always looking at someone who is looking at you!

The first of these difficulties can be dealt with by setting up two mirrors, thereby producing a reflection of a reflection. Unfortunately, though, the second mirror reveals two images, one slightly out of register with the first. When you are drawing, this can become very obvious and rather unsettling.

MATERIALS

Selection of watercolour paints

Chinese brush

No. 2 brush

Cotton swab

Water

Selected pose
I used only one mirror, so I obtained a reversed image of myself. The light source here is daylight from both a window and a skylight. Avoid lighting that reflects back into your eyes.

1 *I chose not to do any preliminary pencil drawing for this water-colour. In this case, make sure that your first brushstrokes are light in tone and neutral in colour – they should guide you without pinning you down.*

2 *Using a mix of burnt sienna and vermilion, I began to delineate some internal shapes – noting, in particular, the alignment of the underside of the wrist with the nose.*

3 *Next, I blocked in areas of tone with warm washes consisting mainly of raw sienna. At this stage, look for patterns of light and dark tone, and warm and cool colours.*

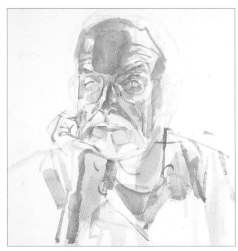

4 *When you have built up enough colour and shape, you can move on to the precise positioning of the facial features. I let the washes dry before proceeding to this detailed work.*

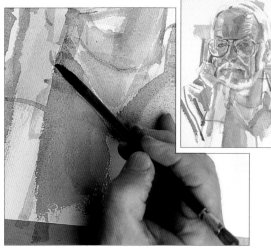

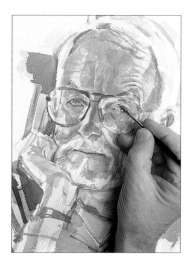

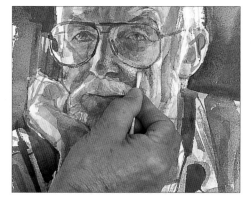

5 *Gradually introduce darker tones. I began to use some cool colours, both in the shadows on the skin and in the hair and beard. With a finer brush, I then placed and defined the eyes.*

6 *Returning to the larger Chinese brush, I washed in some of the strong blue of my shirt.* Inset: *Avoid putting too much detail in the shirt – this only detracts attention from the face.*

7 *Do not overdo the eyes – usually they are not as bright or as large as you first think. Indeed, behind glasses they can almost disappear.*

8 *Now take a break and then re-assess your painting with fresh eyes. I saw a few places where I had lost some of the light-fall. With watercolour, it is possible to wash back colour by using either a small brush or a cotton swab, dipped in clean water.*

The finished drawing

As well as applying new colour to the washed-out corrections, I darkened the whole background to a tone similar to that in the mirror. This allowed me to make slight adjustments to the outline of the head. The dark tone also threw the head into stark relief – a strong background colour is needed to define the edge of my white-haired head!

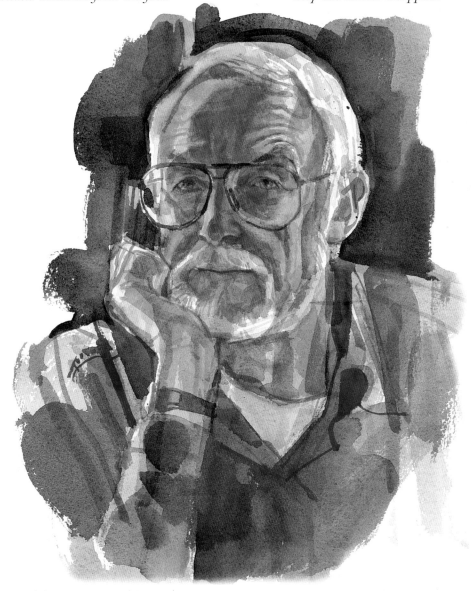

DRESSING UP

In some sittings, elaborate clothing is an important indication of the character of your model; in others it shows an urge on the part of the artist to have some fun and create a drawing full of exciting pattern and colour!

IT CAN BE GOOD FUN to draw a portrait in which the head is almost overwhelmed by a huge hat or other dramatic accessories, and there are any number of precedents in the history of art. Rembrandt loved to dress up for his self-portraits, and one of his most famous paintings is of his brother as a soldier, the helmet burnished and gleaming and completely upstaging the face. Look also at the society portraits of the Austrian artist Gustav Klimt, in which the head and hands of the subject emerge from a mass of richly decorative pattern, often loosely based on the clothes actually worn. Edouard Manet painted Berthe Morisot with her face almost completely hidden behind a fan!

You could do something like this by swathing a figure in scarves or lengths of strongly patterned fabric. Try including a background that either clashes or complements with the colours and patterns of the clothes. This is your chance to be creative – the ensemble need not be fashionable or in good taste, just exciting to draw.

MATERIALS

Selection of coloured inks

Bamboo pen

Chinese brush

No. 2 brush

Selection of watercolour paints

Water

White gouache

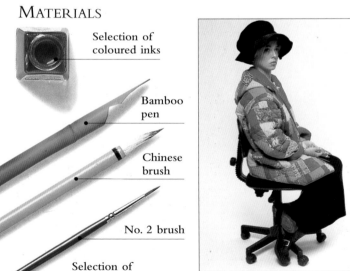

Selected pose
Although the model would not normally choose to match up this large hat with the multi-coloured jacket, the combination gave me the chance to draw some interesting patterns and shapes.

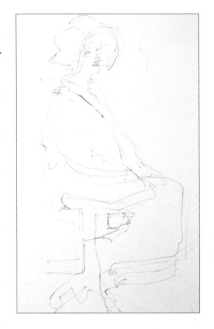

1 *Using a bamboo pen and red, orange and black inks, I drew quickly round the main shapes of the figure and chair. At this stage, keep dipping your pen in water to produce very pale lines that can easily be adjusted by overdrawing later.*

2 *Restarting at the top and using slightly less dilute ink, I drew the head and hat together as a composite shape. As this picture is intended to be a portrait, I thought it best to position the head first.*

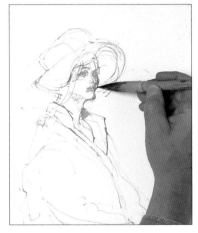

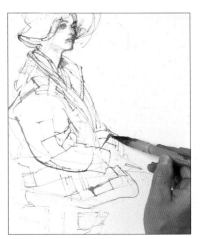

3 *Using more ink and less water, I began to delineate the patches within the overall outline of the jacket. Remember, you should not accept your first drafted outline without question; check and recheck, and be ready to make radical changes with your stronger ink.*

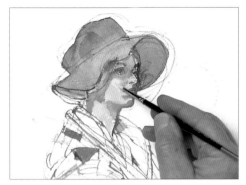

4 *I put in an initial black ink wash on the hat and then introduced transparent washes for the darker shadow areas of the face, and body colour for the lit areas.*

5 *As the skirt, shoes and chair seemed to merge into one dark-toned shape, I paid particular attention to the negative areas to define the model's outline.*

6 *When painting a multicoloured garment, you can save time and effort by putting in all the panels of one colour in a single go.* Inset: *Draw in finer details with the pen.*

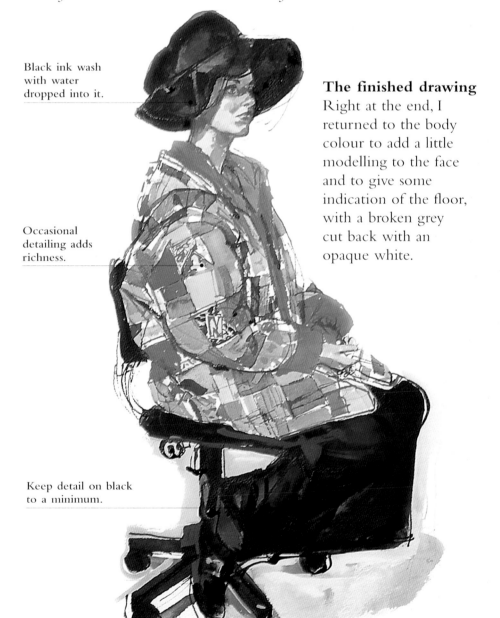

Black ink wash with water dropped into it.

Occasional detailing adds richness.

Keep detail on black to a minimum.

The finished drawing
Right at the end, I returned to the body colour to add a little modelling to the face and to give some indication of the floor, with a broken grey cut back with an opaque white.

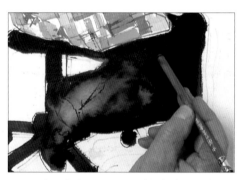

7 *I decided to ignore the light and shade on all the black areas and wash them in with a larger brush and black ink. Don't be afraid to simplify in this way if it adds drama.*

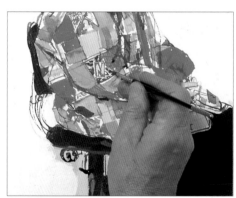

8 *When presented with a complex pattern, it is not necessary to put in every visible detail. I followed the general design of the coat, but only described detail in a few of the panels.*

STRONG TOP LIGHT

A single, strong top light allows you to create a drawing full of dramatic contrast – the figure may appear mysterious, or even sinister, as it is converted into an almost abstract arrangement of light and dark.

THERE IS NO NEED FOR expensive equipment to achieve dramatic top-lighting. Simply put a bright light bulb (about 200 watts) in a ceiling fitting with a shade that directs the light downwards (away from your eyes). Under this type of lighting, take your time to choose a pose that achieves a variety of effects. Select a pose that gives a vibrant arrangement of bright highlighted areas alternated with deep pools of downward-cast shadow. In some sitting poses, the figure may be over-lit without enough contrast. Aim for lighting that strongly accentuates vertical changes of form.

A similar effect can be attained outdoors on a bright summer's day at midday. A slightly reclined figure shows heavily shadowed eyes and an overemphasized form.

STANDING FIGURE

MATERIALS

Charcoal

Black Conté pencil

White Conté stick

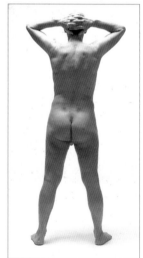

Selected pose
Experiment to find the best pose to exploit this form of lighting. First ask the model to stand directly under the light source, and then gradually adjust his position and pose until the light catches and accentuates a few prominent forms.

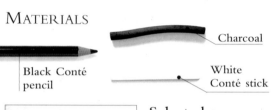

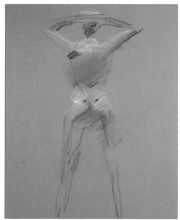

1 *I set out the symmetrical pose using charcoal and soft white Conté, indicating the approximate areas of light-fall. Here, the head is positioned above a point equidistant from each foot.*

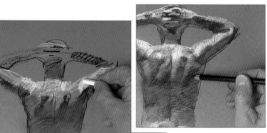

2 *The upper arms and the shoulders combined to make one light-catching form which I now consolidated with the white Conté, while darkening and defining the shadowed back. Inset: To emphasize the strongest tonal changes, I used a black Conté pencil. Working down the body, I allowed more and more grey paper to show through and contribute to the flesh tone.*

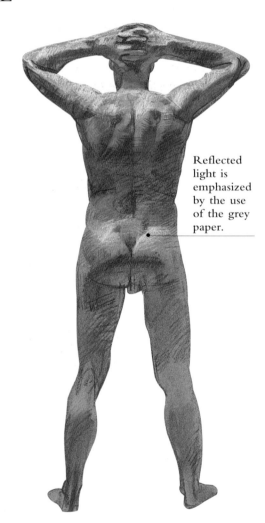

Reflected light is emphasized by the use of the grey paper.

The finished drawing
Cutting-out the figure clearly shows the extent to which the paper colour has contributed to the flesh tones – look in particular at the half-light on the calves and the reflected light on the buttocks.

SITTING FIGURE

MATERIALS

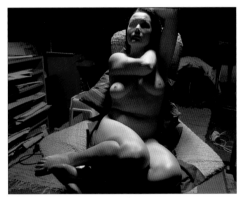

Selection of Conté pencils

Selected pose

Here the powerful downlight breaks up the figure into an almost abstract pattern of light and shadow. Move the model and, if possible, the light source until you find an interesting pattern.

1 *In this Conté pencil drawing, I decided to make no attempt at recording realistic colours. I started by delineating the shadow shapes of the face, neck and arms with a mid-blue, leaving areas of light as plain paper.*

2 *With a darker blue and a bright pink, I tightened up the drawing, adding more precise shapes, and confirming and deepening the tones. Look for the patterns created by the pools of light as well as the shadows.*

3 *While concentrating on the patterns, be careful not to lose sight of the overall figure as it emerges. Where the lower limbs project forward, make sure that you do not underestimate their size – if anything, exaggerate them a little to give a strong base for the figure. Inset: For the darkest tones, rub the chalk in to obtain solid blocks of colour.*

The finished drawing

As this is a study of the unusual light patterns on the figure, it is not necessary to render light and shade over the whole picture area. Here, I have put in some areas of tone immediately adjacent to the figure and the chair, to give the drawing a unifying frame.

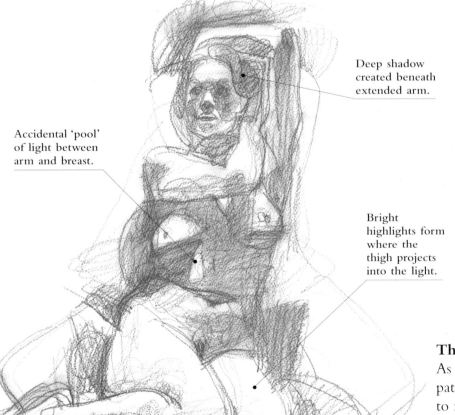

Deep shadow created beneath extended arm.

Accidental 'pool' of light between arm and breast.

Bright highlights form where the thigh projects into the light.

AGAINST THE LIGHT

Drawing against the light dramatizes the sitter with strong tonal contrasts — most of the figure will be rendered in soft shadows and subtle colours, but there will also be bright light skimming the edges.

WHEN DRAWING AGAINST the light (or 'contre-jour'), your model will be rendered predominantly in dark tones, but try to avoid drawing a completely featureless silhouette. Sit close enough to your model to be able to clearly discern the areas of light at the edges of the figure. And, if possible, arrange a few pale-toned surfaces in front of your model so that light is reflected back on to her. This will add some variation and vitality to the shadow areas.

When you come to the drawing, it is often best to plot the brightly lit areas first, as I have done here. Then you can search out the subtle colours in the shadow areas. Often if the back light is warm, the shadows will appear to be rather cool in contrast. In this project, note how I have described the sunlit parts of the model in warm reds and yellows, while the deepest shadows — found under the chin and breasts — are rendered in cool blue-greys. With a cooler light, say from clouded daylight, you may find that the directly lit areas of your model are cooler than the shadows. Remember that the colour and temperature value of the shadow areas will be influenced by the colour of the surroundings.

MATERIALS

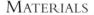

Selection of soft pastels

Selected pose
Posing your model against a window is the most obvious way to set up a contre-jour study. Here, the sunlight was at quite an oblique angle to the model — catching on the right side of her body, and also on her left shoulder, her lap and parts of the front of the torso.

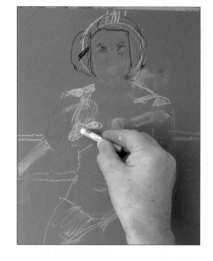

1 *I chose a bright red pastel to map out the main shape and then began to find some of the lit areas with very light raw sienna and rose madder. (In a good range of pastels, you will find that each colour comes in a range of tints — the lightest being almost white.)*

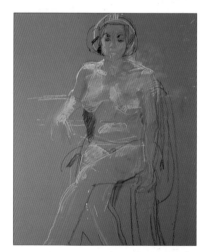

2 *Now I began to define the edge of the figure by putting in the dark blue of the gown draped over the chair. By drawing this gown and the highlights on the shoulders, I established the extremes of light and dark early on. On a dark-toned ground, this makes it much easier to judge the middle tones.*

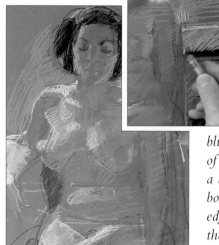

3 *Here, I started to establish the tones of hair, face and background. I refined the light areas and added cool greys and blues to the shaded areas of the figure.* Inset: *With a black pastel I drew the bold line that marks the edge of the window and the main tonal change of the background.*

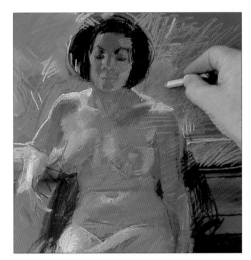

4 *With more cool grey-mauves, I enlivened the reflected light on the shaded side of the figure – these colours were subtle enough not to challenge the dominance of the edge lighting. Some splashes of sunlight were catching the bank of greenery through the window, and I put these in with a bright yellow-green pastel.*

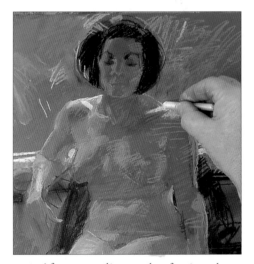

5 *After extending and softening the light-fall on the near thigh and adding a little more modelling on the sitter's left arm, I reinforced the much brighter light on the shoulders with a very light tint of rose madder.*

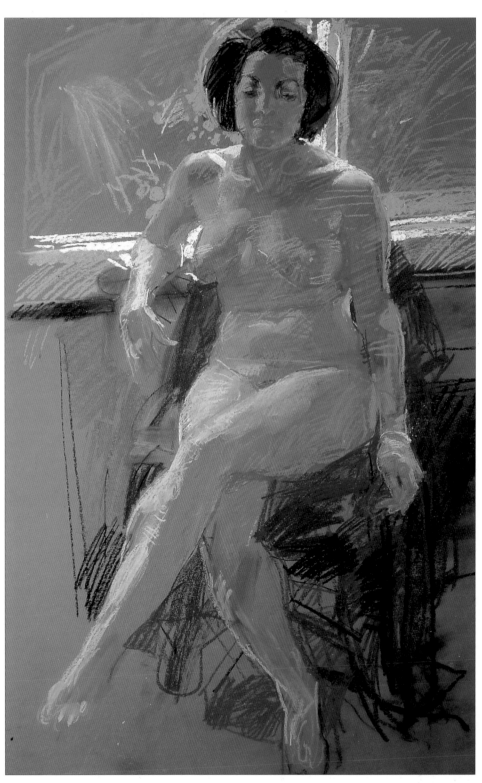

The finished drawing

I left the brightly lit parts of the window frame until the end so I could use bold, once-and-for-all strokes of white pastel for maximum impact. Do not be tempted, though, to use white on the figure – even the palest flesh under the brightest light will have a tone. Keep your pastel drawing lively by applying colour with bold strokes, without too much smoothing together. I scribbled in a tone for the background wall to offset the figure.

PATTERNS OF LIGHT

Light through shutters or slatted blinds can create wonderful patterns
on the body. As the light travels over the model, it seems to both describe
and disguise the form of the figure.

To CREATE LINEAR PATTERNS of light, it is not necessary to install shutters and wait for a sunny day! You can simulate the effect with the aid of a slide projector, as I have done in this project. With a black felt-tip pen, draw a pattern of black stripes on a piece of clear film and put it in a cardboard slide mount, or layer strips of black paper in a glass slide mount.

When light is projected through one of these mounts on to the body, the resulting strips of light transform the figure. As the strips rise and fall over different body parts, they seem to clarify the three-dimensional form. Yet at the same time, they encourage you to read the body as a two-dimensional pattern of light and dark.

This composition was set up to have a small range of colour – mainly warm yellows and oranges, but also the rich tans and browns that result from the addition of black to those colours. I worked on a watercolour board with a semi-rough surface.

MATERIALS

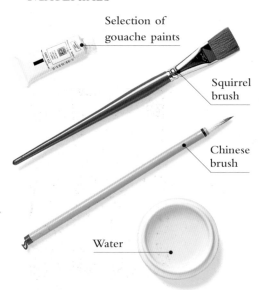

Selection of
gouache paints

Squirrel
brush

Chinese
brush

Water

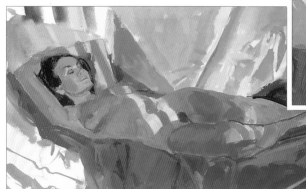

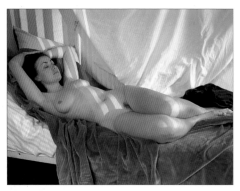

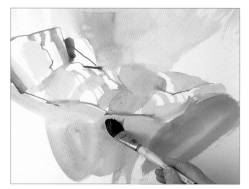

Selected pose
It is best to project your linear patterned slide from quite a low level. A reclining pose is very effective, as this allows the strips of light to travel along the length of the body.

1 *Using a medium-sized Chinese brush with raw sienna and a little orange, I put down the main figure shapes and some of the light pattern. For the background, I used loose washes of raw sienna and a little black.*

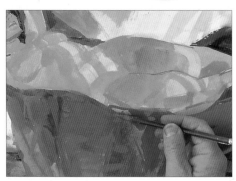

2 *Next, I overlaid further background washes. There is no need to be too exact about the colour of these early washes – their purpose is to deaden the white of the board and to provide a base for later colour.*

3 *Starting from the left, I began to evaluate the warm tones of the body more carefully. Some mid-yellow was introduced into the torso mix and some pink into the face mix. Inset: I began to build up the bars of light with thicker paint – not white, but very pale pinks and yellows.*

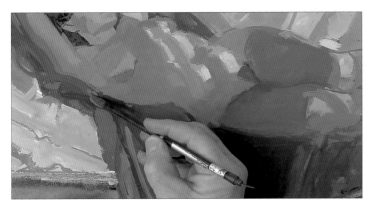

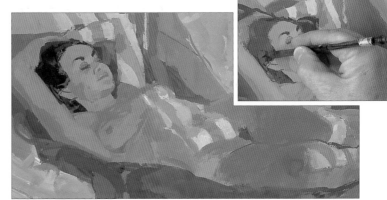

4 *At this point, I felt that my work on the figure had become too tight and was drawing attention away from the drama of the bars of light. Accordingly I stood back, reassessed and repainted all the figure tones and colours with a broader, bolder touch.*

5 *As the session progressed, the model's hips sunk further into the bed. To emphasize this shift, I cut into them from the top side and extended them from the bottom. I began to darken the background to emphasize the projected light further.* Inset: *I then simplified the face and head.*

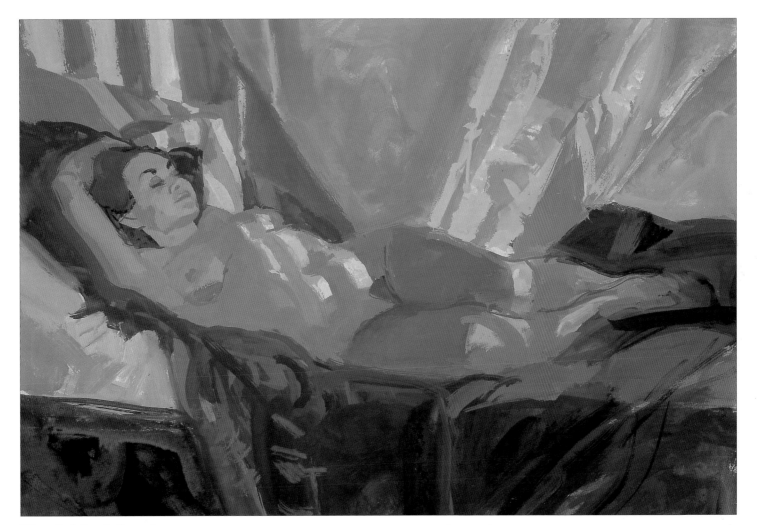

The finished drawing

Compare this finished drawing with step 3 – by moving the position of the hips I feel that I created a more interesting swing to the pose. Although the bars of light have been darkened since the earlier stages, they look brighter as a result of the reduction of all the other tones. There is a lesson to be learned here – never be afraid to make major revisions. Note how the strips of light have helped to describe the rise and fall of the stomach, and yet seem to flatten the model's left arm into a striped design.

INDEX

ACKNOWLEDGEMENTS & PICTURE CREDITS

Author's Acknowledgements
I would like to thank the models: Nikki Donovan, Barry Herbert, Johanna Llewellyn, Francis Nicholls, Louise Pyne, Nadia Rahman-Vais, Matthew Rake, Nigel Sellwood, Claire Sharland, and Rosie, Oliver and Grace Sellwell.

Also, many thanks to Mike Carr for introducing me to word processing, and to Stan Smith, Roger Bristow and Sarah Hoggett for their encouragement and belief, Julia Ward-Hastelow, Katie Bent and the team at Collins and Brown for their help and tolerance, and my wife, Sheila, for all those things and more.

Publisher's Acknowledgements
The publishers would like to thank Sampson Lloyd, Matthew Rake, Ian Kearey and Ingrid Lock for their invaluable contributions to the book.

Picture Credits
All illustrations are copyright John Raynes, except the following: page 6, Sonia Halliday Photographs; page 7 (right), British Museum/Bridgeman Art Library, London; page 9 (left), Ashmolean Museum, Oxford; page 9 (right), Private Collection; page 82, Courtesy of the Board of Trustees of the Victoria and Albert Museum, London.